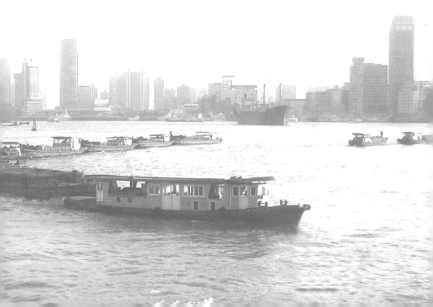

SHANGHAI
architecture & design

Edited and written by Christian Datz & Christof Kullmann
Concept by Martin Nicholas Kunz

teNeues

contents

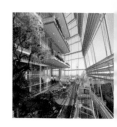

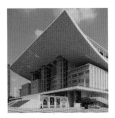

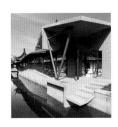

to see . culture & education

to see . public

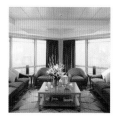

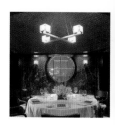

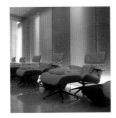 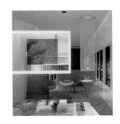

to go . wellness, beauty & sport

to shop . mall, retail, showrooms

index

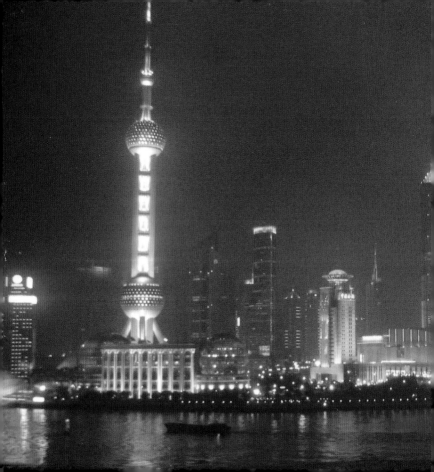

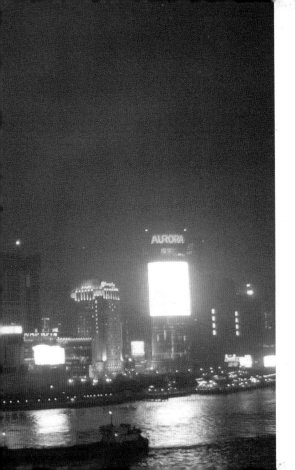

introduction

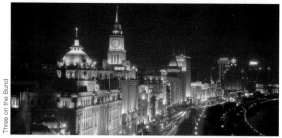

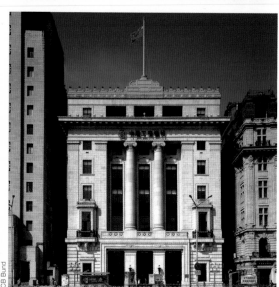

Glass skyscrapers are located alongside traditional buildings, multi-storey freeways cut across historic city districts—that is Shanghai, a city rich in contrasts and almost completely changed over the past decade. The "city above the sea"—the literal translation of 'Shanghai'—has become a "city, which explodes". Numerous models of high-quality architecture and design are located in the almost bewildering mass of new buildings. Above all, at the "Bund", Shanghai's famous riverside promenade, a whole series of historic buildings was recently transformed into magnificent, exclusive "design temples".

Gläserne Wolkenkratzer stehen neben traditionellen Hofhäusern, mehrstöckige Autobahnen durchschneiden historische Stadtviertel – das ist Shanghai, eine Stadt voller Kontraste, die sich in den vergangenen zehn Jahren fast vollständig verändert hat. Aus der „Stadt über dem Meer", so die wörtliche Übersetzung von Shanghai, wurde eine „Stadt, die explodiert". In der fast unüberschaubaren Menge der Neubauten findet sich eine Vielzahl von außergewöhnlichen Architektur- und Designbeispielen von hoher Qualität. Vor allem am „Bund", der berühmten Uferpromenade Shanghais, verwandelten sich in den letzten Jahren eine ganze Reihe historischer Gebäude in prachtvolle, exklusive „Designtempel".

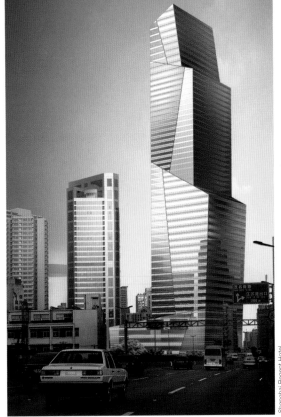

Shanghai Regent Hotel

9

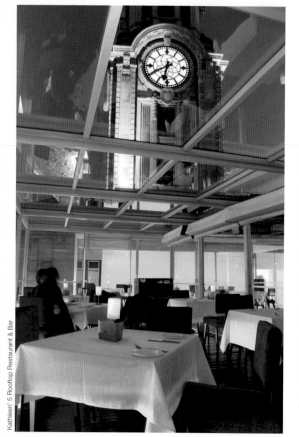

Kathleen' 5 Rooftop Restaurant & Bar

Des gratte-ciel en verre côtoyant des maisons chinoises traditionnelles à cour, des autoroutes à étages traversant les quartiers historiques de la ville – c'est Shanghai, une ville pleine de contrastes qui a presque complètement changé de visage au cours de cette dernière décennie. La « ville au-dessus de la mer », qui est la traduction littérale de Shanghai, est devenue une « ville explosive ». Un grand nombre d'exemples exceptionnels d'architecture et de design de grande qualité émergent de cet océan de nouvelles constructions. Le long de la célèbre promenade de Shanghai, le Bund, beaucoup d'immeubles historiques sont devenus ces dernières années des temples de design éblouissants et exclusifs.

Rascacielos de cristal que se alzan al lado de casas tradicionales y autopistas de varios pisos atravesando los barrios históricos, esto es Shanghai, una ciudad llena de contrastes que, en los últimos diez años, ha experimentado una renovación casi completa. La "ciudad sobre el mar", traducción literal de Shanghai, se ha convertido en una "ciudad en explosión". Entre la inmensa cantidad de nuevas construcciones encontramos un gran número de ejemplos arquitectónicos y de diseño excepcionales y de gran calidad. Pero es especialmente en el "Bund", el famoso paseo marítimo de Shanghai, donde a lo largo de los últimos años se ha asistido a la transformación de un gran número de edificios históricos en exclusivos "templos del diseño".

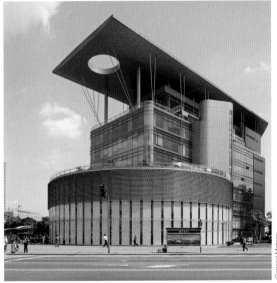

11

to see . living
office
culture & education
public

 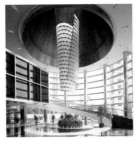 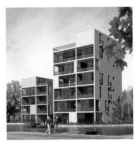

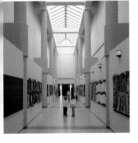 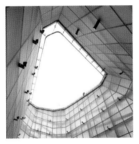 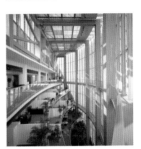

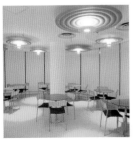 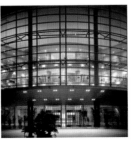 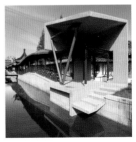

Greenland Show Apartment

dwp CL3 Architects Ltd.

2002
429 Zhonghua Lu
Nanshi

www.cl3.com

In this apartment, normal wall or ceiling lamps do not function as lighting. Instead, the furnishing itself is illuminated: the bar, the low table in the living area and the glass wall, with a kitchen and bathroom concealed behind.

Als Lichtquellen dienen in diesem Apartment nicht normale Wand- oder Deckenleuchten; stattdessen leuchtet die Einrichtung selbst: Die Bar, der niedrige Tisch im Wohnbereich und die gläserne Wand, hinter der sich Küche und Badezimmer verbergen.

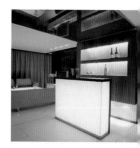

Dans cet appartement, les sources de lumière ne proviennent pas des appliques ou des plafonniers habituels. C'est l'ameublement qui est lumineux : le bar, la table basse dans le séjour et la paroi vitrée, derrière laquelle sont dissimulées la cuisine et la salle de bains.

En este apartamento, las fuentes de luz no son las habituales lámparas de techo o de pared sino el mobiliario mismo: el bar, la mesa baja de la zona del comedor y los tabiques de cristal, detrás de los que se esconden el baño y la cocina.

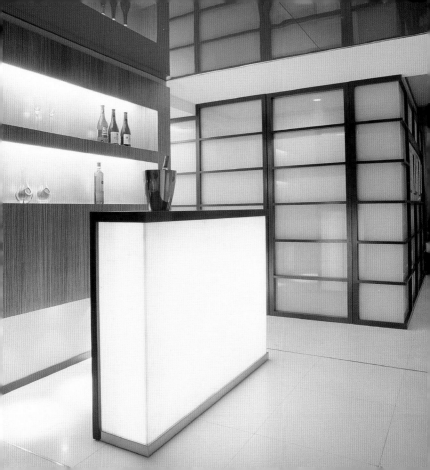

Top of City Lights

B+H Architects – Bregman + Hamann

2004
333 Chengdu Beilu
Jingan

www.bharchitects.com

The residential quarter "Top of the City Lights" is located not far from Century Park in Pudong. Their most striking features are rolling façades and generous window areas covering an entire storey. The luxurious apartments are sized up to 400 m² and offer an impressive, panoramic view of the city skyline.

Die Wohnanlage Top of the City Lights liegt unweit des Century Parks in Pudong. Ihre auffälligsten Merkmale sind die sanft geschwungenen Fassaden und großzügige, geschosshohe Fensterflächen. Die luxuriösen Apartments sind bis zu 400 m² groß und bieten einen beeindruckenden Panoramablick auf die Stadtsilhouette.

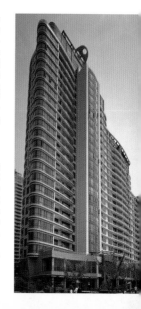

La résidence Top of the City Lights n'est pas très loin du Century Park à Pudong. Ses façades légèrement arquées et ses grandes baies vitrées hautes comme un étage distinguent cet ensemble. Des appartements luxueux avec plus de 400 m² de surface offrent une vue panoramique impressionnante sur la skyline de Shanghai.

El complejo residencial Top of the City Lights está situado cerca del Century Park, en Pudong. Lo más característico de esta construcción son sus fachadas suavemente arqueadas y los amplios ventanales, que van desde el suelo hasta el techo. Los lujosos apartamentos, de hasta 400 m², ofrecen una impresionante vista panorámica del contorno de la ciudad.

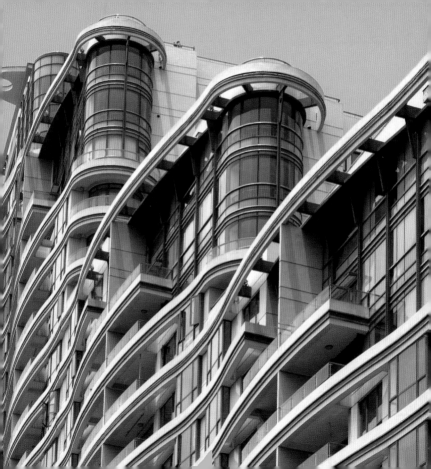

Show House

dwp CL3 Architects Ltd., Rocco Design Limited

2004
599 Fang Dian Lu
Pudong

www.cl3.com
www.roccodesign.com.hk

The villa is intended as a modern interpretation of a traditional house with courtyard. The architectural concept is based on the contrasting principle of Yin and Yang. The pattern of the large wood panels in the living area is supposed to be reminiscent of the illustration of mountains in traditional Chinese painting.

Die Villa ist als moderne Interpretation eines traditionellen Hofhauses gedacht. Das architektonische Konzept beruht auf dem gegensätzlichen Prinzip von Yin und Yang. Die Muster der großen Holzpaneele in der Wohnhalle sollen an die Darstellung von Bergen in der traditionellen chinesischen Malerei erinnern.

La villa est conçue comme une interprétation moderne d'une maison traditionnelle chinoise à cour. Le concept architectural repose sur les deux principes opposés du Yin et du Yang. Les marbrures des grandes boiseries du séjour rappellent les montages caractéristiques de la peinture chinoise traditionnelle.

Esta villa se ha proyectado como la interpretación moderna de una casa tradicional con patio. El concepto arquitectónico está fundamentado en el principio de los contrarios del *ying* y el *yang*. El dibujo de los grandes paneles de madera del salón evoca la representación de las montañas en la pintura tradicional china.

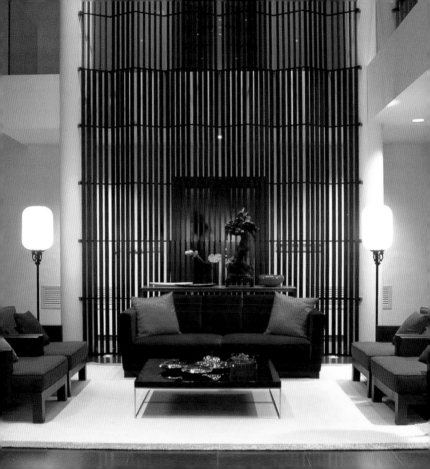

Longyang Residential

MADA s.p.a.m.

2003
Longyang Lu
Pudong

www.madaspam.com

The Longyang residential complex clearly differs from the usual repetitious style of mass apartment construction in Shanghai. Instead of anonymous, uniform façades, the buildings are characterized by a differentiated color scheme and the changing play of balcony designs.

Der Longyang-Wohnkomplex unterscheidet sich deutlich von dem in Shanghai vielfach üblichen Massenwohnungsbau. Statt anonymer, gleichförmiger Fassaden werden die Gebäude durch eine differenzierte Farbgebung und das wechselnde Spiel der Balkongestaltungen geprägt.

La résidence de Longyang se distingue nettement de la construction de masse très répandue à Shanghai. Des couleurs et des balcons différents viennent égayer dans ce complexe des façades habituellement anonymes et uniformes.

El complejo residencial Longyang se diferencia claramente de la típica construcción masiva de viviendas de Shanghai. En lugar de las fachadas anónimas y uniformes, los edificios se singularizan por un cromatismo diferenciado y el caprichoso juego del diseño de los balcones.

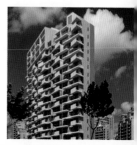

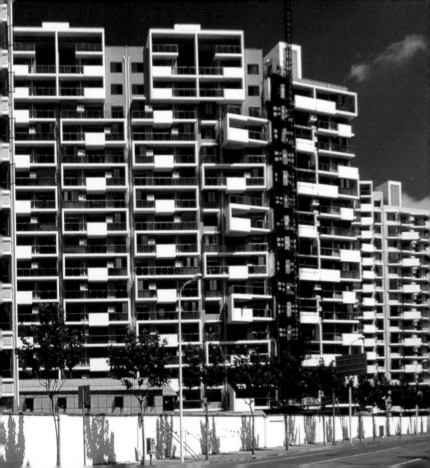

De Oriental London

Steve Leung

2002
1000 Gubei Lu
Changning

www.steveleung.com

In this apartment, traditional Chinese influences unite with modern design ideas. The living quarters are sectioned off by black wall partitions. In front of them, the light furniture is set off to good effect. The skillful use of mirrors underlines the spacious and multi-layered overall look.

In diesem Apartment vereinen sich traditionelle chinesische Einflüsse mit modernen Gestaltungsideen. Der Wohnraum wird von schwarzen Wandscheiben begrenzt, vor denen sich die hellen Möbel effektvoll abheben. Der raffinierte Einsatz von Wandspiegeln unterstreicht den großzügigen und vielschichtigen Gesamteindruck.

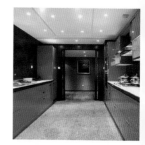

Cet appartement est la synthèse d'influences chinoises traditionnelles et modernes. L'espace est délimité par des cloisons noires qui font ressortir la couleur claire des meubles. Des miroirs ingénieusement placés soulignent l'impression générale de place et de diversité.

En este apartamento se fusionan las influencias tradicionales chinas con los conceptos del diseño moderno. El salón está delimitado por las placas negras de las paredes, fondo sobre el que resaltan de forma efectista los muebles de colores claros. El inteligente empleo de espejos de pared acentúa la amplitud y la complejidad de la impresión del conjunto.

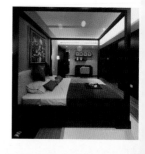

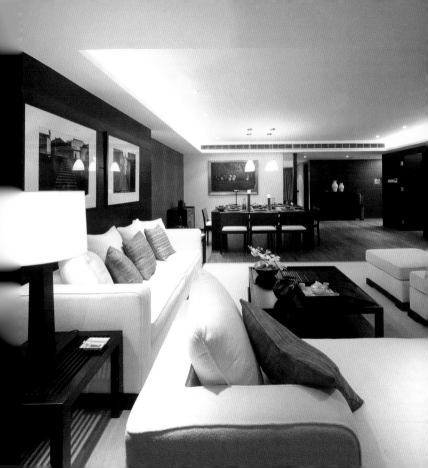

Winter
The Manhattan Shanghai

Steve Leung

2002
128 Hong Qiao Lu
Changning

www.steveleung.com

The theme given for designing this apartment was the atmosphere on a cold winter's day. Hard, black and white contrasts and glass wall objects underline the cool atmosphere. Occasional soft-green color tones hint at the feel of the first days of spring.

Die Stimmung eines kalten Wintertages war die thematische Vorgabe für die Gestaltung dieser Wohnung. Harte Schwarzweißkontraste und gläserne Wandobjekte unterstreichen die kühle Atmosphäre. Wenige lindgrüne Farbakzente lassen eine Vorahnung auf die ersten Frühlingstage zu.

Dans cet appartement, il s'agissait de créer une ambiance hivernale. Les contrastes marqués en noir et blanc et les éléments vitrés viennent renforcer une atmosphère froide. Quelques touches de couleur vert tilleul sont annonciatrices des premiers jours de printemps.

El diseño de esta vivienda está inspirado en el ambiente de un frío invernadero. Los duros contrastes entre el blanco y el negro y los elementos de cristal de las paredes, subrayan la fría atmósfera. Acentos de color verde claro dejan presentir la llegada de los primeros días de la primavera.

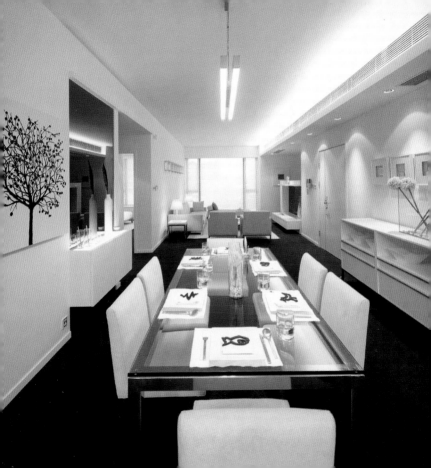

Autumn
The Manhattan Shanghai

Steve Leung

2002
128 Hong Qiao Lu
Changning

www.steveleung.com

Simple, clear lines and a carefully balanced choice of color for the furnishing and wall surfaces are to give this apartment a tranquil, autumnal atmosphere. Two wall partitions—clad in Zebrano and light oak—divide the dining area from the living quarters.

Einfache, klare Linien und eine sorgfältig abgestimmte Farbwahl der Möbel und Wandoberflächen sollen diesem Apartment eine ruhige, herbstliche Stimmung verleihen. Zwei Wandscheiben – verkleidet mit Zebrano und hellem Eichenholz – trennen den Essbereich von den Wohnräumen.

Les lignes simples et claires et l'heureux assortiment de couleurs qui caractérisent les meubles et les surfaces des murs, confèrent à cet appartement une atmosphère paisible et automnale. Deux cloisons, habillées de zebrano et de chêne clair, séparent la salle à manger des autres pièces de l'appartement.

Las líneas claras y sencillas y una selección cromática cuidadosamente armonizada de los muebles y de las superficies de las paredes, dotan a este apartamento de una atmósfera tranquila y otoñal. Dos tabiques revestidos con madera de zebrano y de haya de color claro, separan la zona del comedor de las habitaciones.

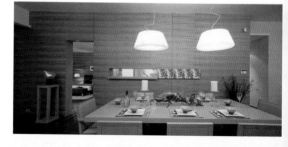

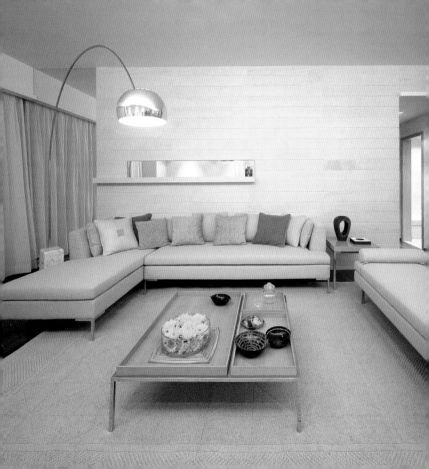

Anting New Town

AS&P – Albert Speer & Partner GmbH

2006
Anting

www.antingnewtown.com
www.as-p.de

Anting is one of the new satellite towns, which were supposed to reduce the pressure of inner-city growth in Shanghai. The client wanted Anting New Town built in the style of a German city—but the architectural plans for the apartments were adapted to Chinese needs.

Anting ist eine der neuen Satellitenstädte, durch die der Wachstumsdruck auf die Innenstadt von Shanghai reduziert werden soll. Auf Wunsch der Auftraggeber wurde Anting New Town dem Charakter einer deutschen Stadt nachempfunden – die Wohnungsgrundrisse jedoch sind auf chinesische Bedürfnisse abgestimmt.

Anting est l'une des nouvelles villes satellites créées pour réduire la pression de la croissance sur le centre de Shanghai. A la demande du commanditaire, Anting New Town a été conçue à l'image d'une ville allemande, mais les plans des appartements ont été adaptés aux besoins des Chinois.

Anting es una de las nuevas ciudades satélites creadas para reducir la presión que el crecimiento está ejerciendo sobre el centro de Shanghai. Por deseo del ordenante, Anting New Town debía tener el carácter de una ciudad alemana, aunque las plantas de las viviendas están adaptadas a las necesidades chinas.

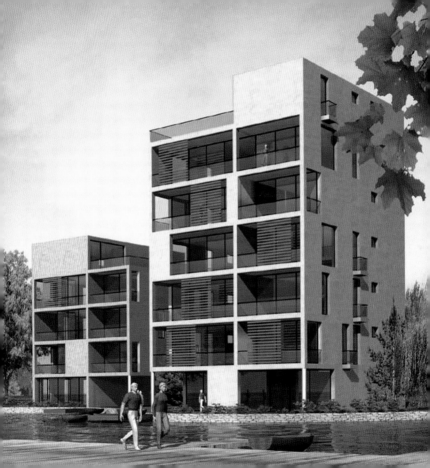

Luchao Harbour City

gmp Architekten – von Gerkan, Marg und Partner

2020
Luchao

www.gmp-architekten.de

Luchao Harbor City created a new city district in Shanghai, which is to provide space for 800.000 residents in an area of 65 km². This makes Luchao one of the largest new city developments for a century. A circular lake of 2.5 km diameter forms the center with a lakeside promenade and bathing beach.

Mit Luchao Harbour City entsteht ein neuer Stadtteil von Shanghai, der auf 65 km² Platz für 800.000 Einwohner bieten soll. Damit ist Luchao eine der größten Stadtgründungen der letzten hundert Jahre. Das Zentrum bildet ein kreisrunder See von 2,5 km Durchmesser mit Seepromenade und Badestrand.

Luchao Harbour City constituera un nouveau quartier de Shanghai qui, sur une surface de 65 km², est destiné à accueillir 800 000 habitants. Luchao est ainsi l'une des plus grandes villes nouvelles du siècle dernier. Un lac en forme de cercle d'un diamètre de 2,5 km avec une promenade et une plage forme le cœur de ce quartier.

Con Luchao Harbour City surge un nuevo barrio de Shanghai que, con sus 65 km², ofrece espacio para 800.000 habitantes. Esto convierte a Luchao en uno de los suburbios más grandes fundados en los últimos cien años. El centro lo ocupa un lago circular de 2,5 km de diámetro que incluye una zona de paseo y una playa para bañarse.

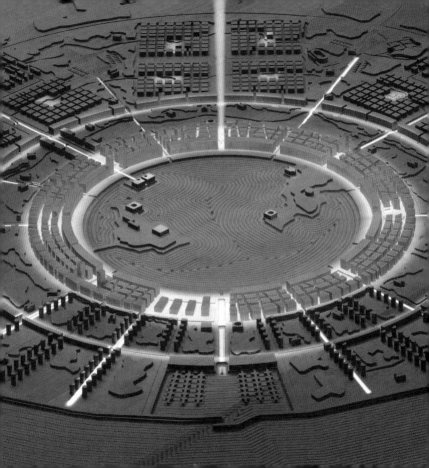

Jie Fang Daily News Headquarters

KMD Architects – Kaplan McLaughlin Diaz

2006
Henan Zhonglu
Huangpu

www.kmdarchitects.com

The extraordinary new building is located on a relatively small plot directly next to the publisher's existing high-rise block. Both buildings are connected by two skywalks. At the south-eastern end, the tower declines to street level in a series of steps. This is how glass atria are created, the so-called "Sky Gardens".

Der außergewöhnliche Neubau befindet sich auf einem relativ kleinen Grundstück unmittelbar neben dem bestehenden Verlagshochhaus. Zwei Stege in luftiger Höhe verbinden beide Gebäude. Im Südosten treppt sich der Turm zur Straße hin ab. Dadurch entstehen verglaste Atrien, die so genannten „Sky-Gardens".

Ce nouveau bâtiment original se trouve sur un terrain relativement petit tout près de la tour de la maison d'édition. Deux passerelles aériennes relient les deux bâtiments. Au sud-est, la tour descend en forme d'escalier côté rue. Il en résulte des atriums vitrés que l'on appelle « Sky-Gardens ».

Este excepcional edificio nuevo se levanta en un terreno relativamente pequeño y justo al lado del rascacielos de la editorial, de construcción anterior. Dos pasarelas, situadas a gran altura, unen ambos edificios. Por la cara sudeste, la torre desciende escalonadamente hasta la calle dando lugar a atrios acristalados, los llamados sky gardens.

Industrial & Commercial Bank of China

Bund Branch Renovation

Joseph Wong Design Associates, Inc.
Shanghai Design Institute (SE)

2001
24 Zhongshan Dong 1-Lu (The Bund)
Huangpu

www.jwdainc.com

The original condition of the bank building was extensively recreated with a comprehensive program of renovation, which still included the technical capacity of a modern office block. The representative character of the interior rooms is underlined by use of high-quality materials.

Durch eine umfassende Renovierung wurde der Originalzustand des Bankgebäudes weitgehend wiederhergestellt, dabei jedoch der technische Standard eines modernen Bürobaus integriert. Edle Materialien unterstreichen den repräsentativen Charakter der Innenräume.

Grâce à une rénovation complète, la banque a retrouvé dans une très large mesure son visage d'origine tout en remplissant les conditions techniques d'un immeuble moderne. A l'intérieur, des matériaux nobles soulignent le caractère représentatif de cette construction.

Gracias a un amplio proceso de saneamiento, se consiguió que el edificio del banco pudiera recobrar su estado original, aunque integrando los estándares técnicos de una construcción moderna de oficinas. Los materiales nobles subrayan el carácter representativo de los espacios interiores.

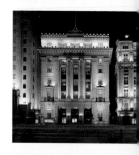

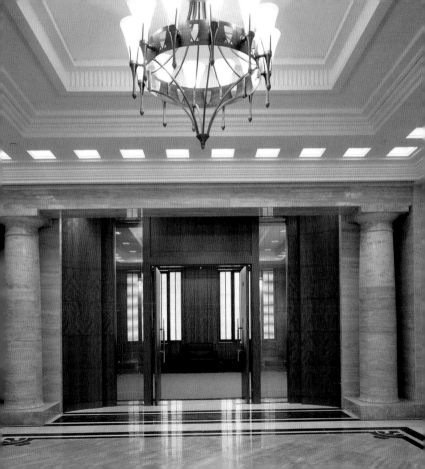

Jiushi Corporation Headquarters

Foster and Partners
East China Architectural Design Institute
Obayashi Corporation Design Department (SE)

2000
28 Zhongshan Nanlu
Nanshi

www.fosterandpartners.com

The elegantly rolling building makes a unique view possible from many of the offices. The view extends over the Huang-Pu river as far as Pudong. The multi-layered, rear ventilation system of the façade filters a maximum amount of daylight, yet without overheating the interior offices during the summer.

Das elegant geschwungene Gebäude ermöglicht aus einer Vielzahl von Büros einen einzigartigen Blick über den Huang-Pu-Fluss bis nach Pudong. Das mehrschichtige, hinterlüftete Fassadensystem erlaubt eine maximale Ausbeute an Tageslicht, ohne dass sich die Innenräume im Sommer übermäßig aufheizen.

Ce bâtiment aux formes arquées élégantes abrite un grand nombre de bureaux qui ont une vue imprenable sur le fleuve Huang-Pu jusqu'à Pudong. Un système de façades aérées et composées de plusieurs couches permet de profiter au maximum de la lumière du jour sans qu'il fasse pour autant trop chaud dans les bureaux en été.

Este elegante edificio, de fachada ligeramente arqueada, hace posible que muchas de las oficinas puedan disfrutar de una vista única sobre el río Huang-Pu y Pudong. El sistema de la fachada cortina de múltiples capas permite el aprovechamiento completo de la luz diurna, sin que esto suponga un sobrecalentamiento de los espacios en verano.

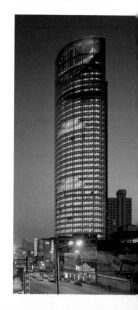

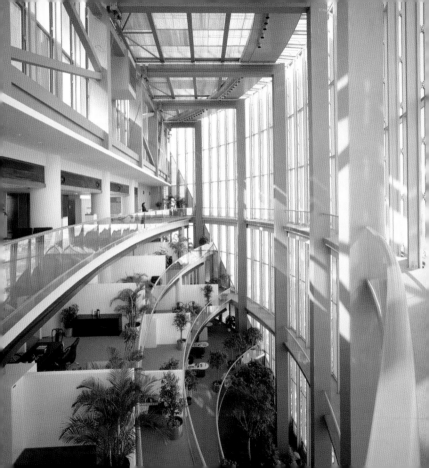

SYWG BNP
Paribas Asset Management

iaction – Interior Action Ltd.

2003
300 Huai Hai Zhonglu
Luwan

The plane trees, which are everywhere, were at one time imported from France to Shanghai. As a reminder of this, the offices of the Chinese-French company were designed according to the abstract concept of a tree in growth.

Die allgegenwärtigen Platanen wurden einst von Frankreich aus in Shanghai eingeführt. Als Reminiszenz daran wurden die Büroräume des chinesisch-französischen Unternehmens nach dem abstrakten Leitbild eines wachsenden Baumes gestaltet.

Les platanes que l'on voit partout dans la ville de Shanghai ont été importés autrefois de France. En souvenir de cette époque, les locaux de bureau de la société franco-chinoise ont été conçus d'après le modèle abstrait d'un arbre en croissance.

Los omnipresentes plátanos fueron importados a Shanghai desde Francia. En memoria de este hecho, los despachos de esta empresa franco-china fueron diseñados según la idea abstracta de un platanero.

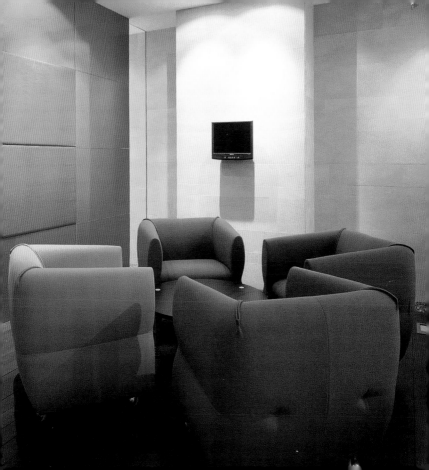

BP China Ltd.

iaction – Interior Action Ltd.

2001
1266 Nanjing Xilu
Jingan

A sundial in the colors of green and yellow characterizes BP's image. The design of the firm's offices in Shanghai in many ways reflects the colors and forms of the company's logo. The open-plan office space maximizes flexibility.

Ein Sonnenrad in den Farben Grün und Gelb prägt das Erscheinungsbild von BP. Im Design der Büroräume des Unternehmens in Shanghai spiegeln sich Farben und Formen des Firmenlogos in vielfacher Weise wider. Der offene Bürogrundriss ermöglicht ein Maximum an Flexibilität.

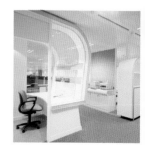

Un soleil vert et jaune caractérise la présentation de BP. Les couleurs et les formes du logo du groupe sont reprises de multiples manières dans le design des bureaux. Les espaces sont ouverts et offrent de nombreuses possibilités d'aménagement.

Una rueda solar en los colores verde y amarillo caracteriza la imagen de BP. Los colores y las formas del logotipo de la empresa se reflejan de muy diversas formas en el diseño de los despachos de su empresa en Shanghai. La planta abierta de las oficinas permite el máximo de flexibilidad.

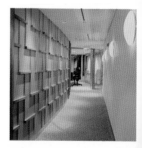

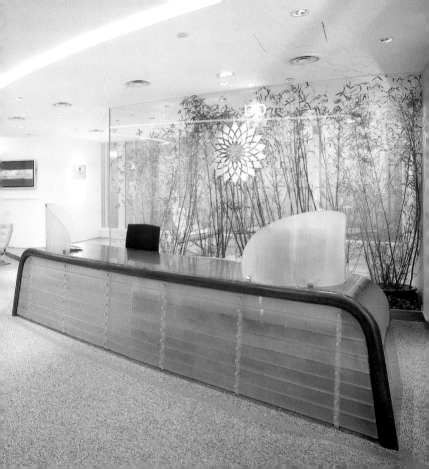

Plaza 66

Kohn Pedersen Fox Associates
Thornton Tomasetti Engineers (SE)

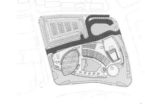

2001
1266 Nanjing Xilu
Jingan

www.kpf.com

An ambitious composition of different buildings makes the enormous spatial floor plan of a shopping mall and two high-rise office blocks an impressive architectural ensemble. That is how the massive complex, despite its dimensions, is integrated into the scale of neighboring city structures.

Eine anspruchsvolle Komposition aus verschiedenen Baukörpern formt das enorme Raumprogramm einer Shopping Mall und zweier Bürohochhäuser zu einem beeindruckenden architektonischen Ensemble. Dadurch integriert sich der gewaltige Komplex trotz seiner Dimensionen in den Maßstab der umgebenden Stadtstrukturen.

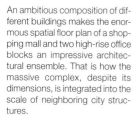

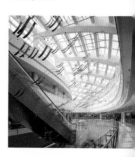

Une composition ambitieuse de différents éléments qui abrite le vaste programme d'une Shopping Mall et deux immeubles de bureaux. Malgré ses dimensions gigantesques, cet ensemble architectural impressionnant s'adapte parfaitement à l'échelle des structures urbaines avoisinantes.

La compleja composición de los diferentes volúmenes, convierte el enorme espacio donde se alojan un centro comercial y dos edificios de oficinas, en un impresionante conjunto arquitectónico. De esta forma, este enorme complejo se integra, a pesar de sus dimensiones, en la escala de los edificios que lo rodean.

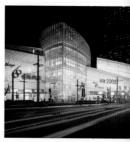

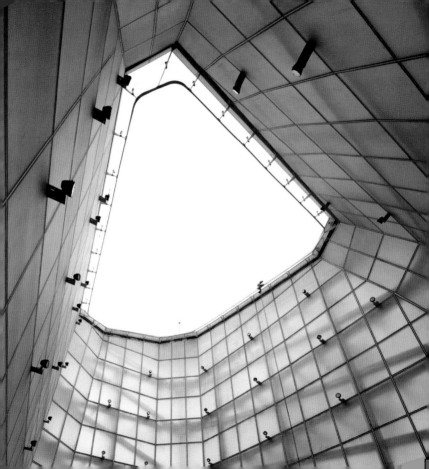

Jin Mao Tower

Skidmore, Owings & Merrill LLP

1998
88 Shiji Dadao (Century Avenue)
Pudong

www.som.com

Regular recesses structure the tower, which is over 420 m high. The recesses are reminders of the traditional form language of Chinese pagodas. This and the differentiated steel-glass façades make Jin Mao Tower one of the most prominent high-rise blocks on Shanghai's skyline.

Regelmäßige Rücksprünge gliedern den über 420 m hohen Turm und erinnern an die traditionelle Formensprache chinesischer Pagoden. Dies und die differenzierten Stahl-Glas-Fassaden machen den Jin Mao Tower zu einem der prominentesten Hochhäuser in der Skyline von Shanghai.

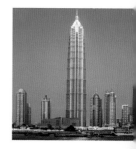

Des retraits réguliers structurent la tour haute de 420 m et rappellent les formes traditionnelles des pagodes chinoises. Avec cette architecture originale et ses différentes façades d'acier et de verre, la Jin Mao Tower est l'immeuble le plus en vue dans la skyline de Shanghaï.

Esta torre de más de 420 m de altura está dividida por recesiones angulares que recuerdan al tradicional lenguaje formal de las pagodas chinas. Esta característica, junto con las fachadas diferenciadas de acero y cristal, convierten a la Jin Mao Tower en uno de los rascacielos más destacados de silueta de Shanghai.

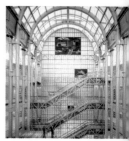

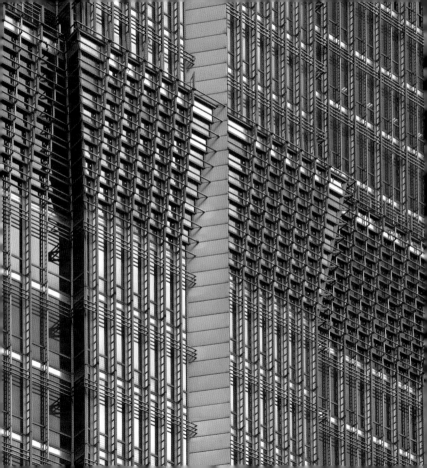

Bank of China Tower

Nikken Sekkei Ltd.

2000
200 Yincheng Zhonglu
Pudong

www.nikkensekkei.com

The skyscraper is located one of the most important intersections between the airport and city center. The lentoid glass shaft of the high-rise building emerges from the column structure, designed on a square layout.

Das Hochhaus liegt an der wichtigsten Verbindungsstraße zwischen dem Flughafen und der Innenstadt. Der linsenförmige gläserne Schaft des Hochhauses erhebt sich aus einem Sockelbau auf quadratischem Grundriss.

L'édifice est situé près de l'axe routier le plus important qui relie l'aéroport au centre-ville. Son fût lenticulaire et vitré s'appuie sur un socle carré.

Este rascacielos está situado en una de las calles de conexión más importantes entre el aeropuerto y el centro de la ciudad. El cuerpo del edificio, acristalado y con forma lenticular, se levanta sobre una base de planta cuadrada.

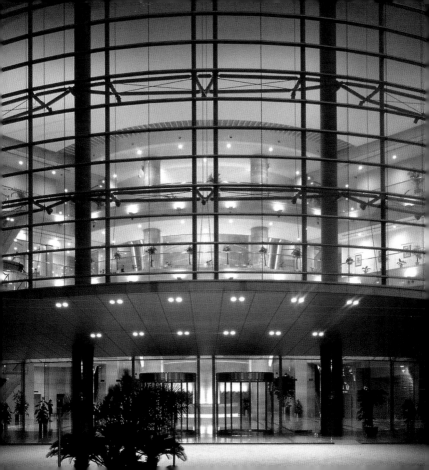

ANZ Bank Shanghai Branch

iaction – Interior Action Ltd.

1999
101 Yincheng Donglu
Pudong

Simple raw materials are intended to reflect the landscape of Australia and New Zealand, as implied in the abbreviation of the bank's name. Modern, high-quality materials are also used as a contrast to this style.

Einfache, rohe Materialien sollen den landschaftlichen Charakter von Australien und New Zealand reflektieren, die sich hinter der Abkürzung im Namen der Bank verbergen. Im Kontrast dazu finden aber auch moderne, hochwertige Werkstoffe Verwendung.

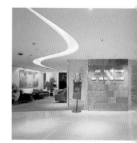

Des matériaux simples et bruts ont été utilisés pour évoquer le paysage d'Australie et de Nouvelle-Zélande qui se cache derrière l'abréviation et le nom de la banque. En contraste, des matériaux modernes de haute qualité ont également été employés.

Los materiales sencillos y sin tratar quieren reflejar el carácter paisajístico de Australia y Nueva Zelanda, nombres que se esconden tras las siglas del nombre del banco. Como contraste se han empleado también materiales modernos de alta calidad.

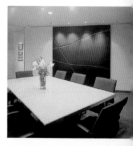

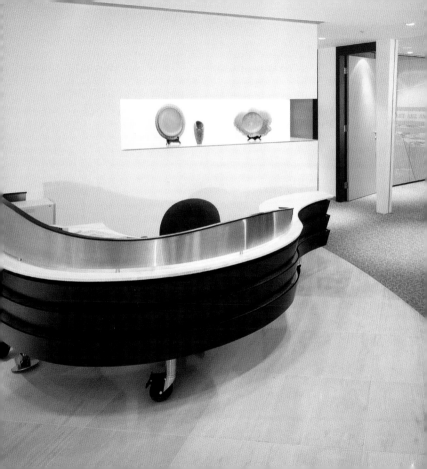

World Financial Center Shanghai

Kohn Pedersen Fox Associates
Leslie E. Robertson Associates (SE)

2008
Shiji Dadao (Century Avenue)
Pudong

www.kpf.com
www.lera.com

The world's tallest building is created here with 101 floors and a height of 492 m. The circular opening at the top of the skyscraper is to reduce wind forces. A spectacular, open viewing platform is planned at the summit for anyone who is especially courageous.

Mit 101 Stockwerken und 492 m Höhe entsteht hier das höchste Gebäude der Welt. Durch die kreisförmige Öffnung in der Spitze des Wolkenkratzers sollen die Windkräfte reduziert werden. Für besonders Mutige ist an dieser Stelle eine spektakuläre offene Aussichtsplattform vorgesehen.

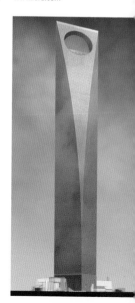

Avec 101 étages et une hauteur de 492 m, ce sera l'immeuble le plus élevé du monde. L'ouverture en forme de cercle au sommet du gratte-ciel est destinée à réduire la force du vent. Une plateforme ouverte est prévue à cet endroit pour offrir aux plus courageux une vue panoramique sur la ville.

Con sus 101 pisos y sus 492 metros de altura, este es el edificio más alto del mundo. Su abertura circular en la parte superior está pensado para reducir la fuerza del viento. Aquí se ha dispuesto una espectacular plataforma abierta panorámica para los más valientes.

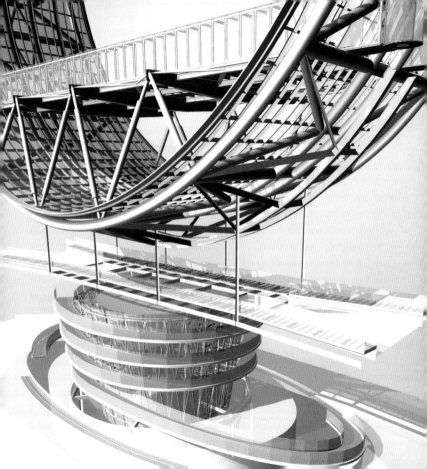

Shanghai Information Tower

Nikken Sekkei Ltd.
Shanghai Institute of Architectural Design & Research (SIADR)

2001
211 Shiji Dadao (Century Avenue)
Pudong

www.nikkensekkei.com
www.siadr.com.cn

The static system of the 288 m high tower consists of two central buttresses, with the individual floors located in-between. A museum for communication is also located in the building along with office and technical facilities.

Das statische System des 288 m hohen Turms besteht aus zwei aussteifenden Kernen, zwischen denen die einzelnen Geschossebenen liegen. Neben Büro- und Technikflächen befindet sich in dem Gebäude auch ein Museum für Kommunikation.

Le système statique de la tour haute de 288 m comprend deux noyaux renforcés entre lesquels se trouvent les différents étages. Outre des bureaux et des locaux techniques, ce bâtiment abrite un musée de la communication.

El sistema estático de la torre de 288 m está formado por dos núcleos reforzados entre los que se sitúan los pisos. Además de despachos y superficies técnicas, la torre acoge también un museo de comunicación.

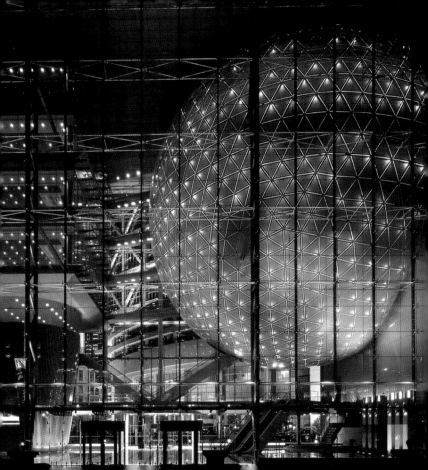

Regional Headquarter Offices Pudong District

Fox & Fowle Architects, Joseph Wong Design Associates,
STUDIOS, Team 7

2001
9 Pudong Avenue
Pudong

www.foxfowle.com
www.jwdainc.com

A building with two different sides: one is based on a rolling design; the other is strictly geometrical. Onyx panels with rear lighting and an impressive light sculpture dominate the foyer.

Ein Gebäude mit zwei unterschiedliche Seiten: Die eine ist sanft geschwungen, die andere streng geometrisch gegliedert. Das Foyer wird von hinterleuchteten Onyxtafeln und einer beeindruckenden Lichtskulptur beherrscht.

Le bâtiment a deux visages : d'un côté, il est légèrement arqué, de l'autre, il est strictement géométrique. Les panneaux en onyx, éclairés par derrière, et une sculpture lumineuse impressionnante occupent une place dominante dans le hall.

Un edificio con dos caras diferentes: la una, suavemente arqueada y, la otra, con una estructura geométrica. La entrada está dominada por la iluminación de fondo de las planchas Onyx y una impresionante escultura de luz.

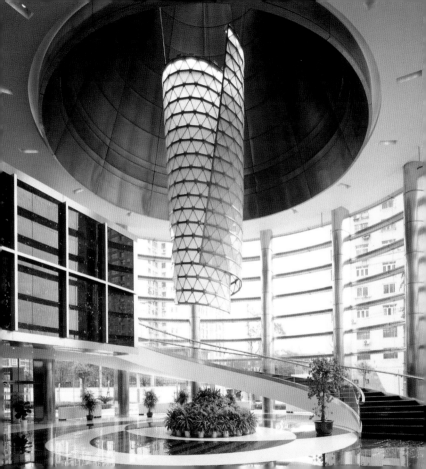

General Motors

Arte Charpentier & Associates

2004
Shiji Dadao (Century Avenue)
Pudong

www.arte-charpentier.com

The Chinese Headquarters of General Motors is distinguished by an impressive roof construction. The roof appears to be suspended and emphasizes the horizontal structure of the building, creating an exciting contrast to the high-rise buildings in the neighborhood.

Die chinesische Zentrale von General Motors zeichnet sich durch ihre beeindruckende Dachkonstruktion aus. Das scheinbar schwebende Dach betont die horizontale Gliederung des Gebäudes und schafft einen spannenden Kontrast zu den Hochhäusern in der Umgebung.

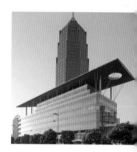

La centrale chinoise de General Motors se distingue par un toit à la construction originale. Le toit en suspension apparente souligne la structure horizontale du bâtiment qui forme un contraste marqué avec les immeubles du voisinage.

La central china de General Motors destaca por la impresionante estructura de su cubierta. El tejado, que parece estar flotando, acentúa la división horizontal de la construcción y crea un interesante contraste con los edificios de su alrededor.

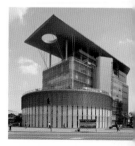

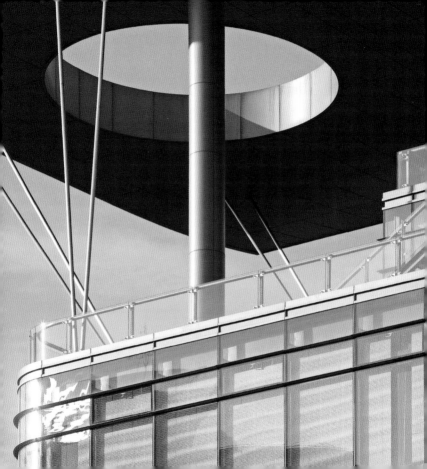

Industrial & Commercial Bank of China Data Center

Joseph Wong Design Associates
Tongji University Design Institute (SE)

2002
80 Tai Nanlu
Pudong

www.jwdainc.com

The data processing center of the Industrial & Commercial Bank of China is located on a campus outside Shanghai city center. An administrative building, training suite with its own hotel and auditorium as well as lavishly designed leisure facilities also belong to this site.

Das Rechenzentrum der Industrial & Commercial Bank of China liegt als Campus außerhalb des Zentrums von Shanghai. Zu der Gesamtanlage gehören auch ein Verwaltungsgebäude, ein Trainingszentrum mit dazugehörigem Hotel und Auditorium sowie aufwendig gestaltete Freibereiche.

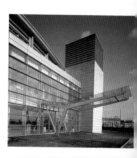

Le centre des comptes de la Industrial & Commercial Bank of China est un campus situé à l'extérieur du centre de Shanghai. Ce complexe comprend également un bâtiment administratif, un centre de formation avec hôtel et auditorium ainsi que des espaces de loisirs luxueusement aménagés.

El centro de cálculo del Industrial & Commercial Bank of China, como campus universitario, está situado fuera del centro de Shanghai. La instalación completa incluye un edificio administrativo, un centro de entrenamiento con hotel y auditorio, y zonas al aire libre de detallado diseño.

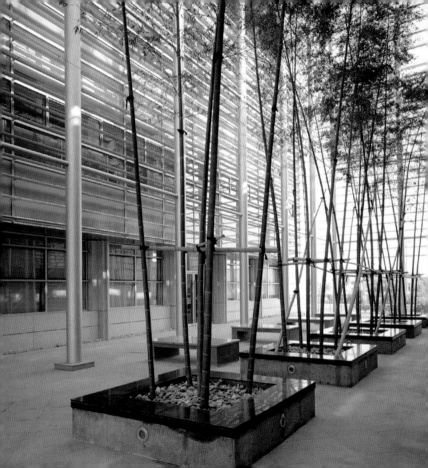

Administration Center Zhang Jiang Mansion

AS&P - Albert Speer & Partner GmbH, deshaus
East China Architectural Design Institute (ECADI)

2004
560 Song Tao Lu
Pudong

www.as-p.de
www.deshaus.com

Zhang Jiang High-Tech-Park is one of the most important development areas in Shanghai. The twin towers of the administrative headquarters of the High-Tech-Park is an important model, due to its dual façade—by no means an usual sight in China—for all other building projects in the park.

Der High-Tech-Park Zhang Jiang ist eines der wichtigsten Entwicklungsgebiete in Shanghai. Der Doppelturm der Verwaltung des High-Tech-Parks hat durch seine – in China noch längst nicht üblichen – Doppelfassaden eine wichtige Vorbildfunktion für alle weiteren Bauprojekte des Parks.

Le parc de haute technologie Zhang Jiang représente l'une des zones de développement les plus importantes de Shanghai. La double tour de l'administration du High-Tech-Park avec ses doubles façades – pas encore très répandues en Chine – a un rôle de modèle important pour tous les autres projets de construction du parc.

El parque de alta tecnología Zhang Jiang es una de las áreas de desarrollo más importantes de Shanghai. La torre doble de la administración es un importante modelo para otros proyectos constructores del parque por su fachada doble, un elemento poco usual en China.

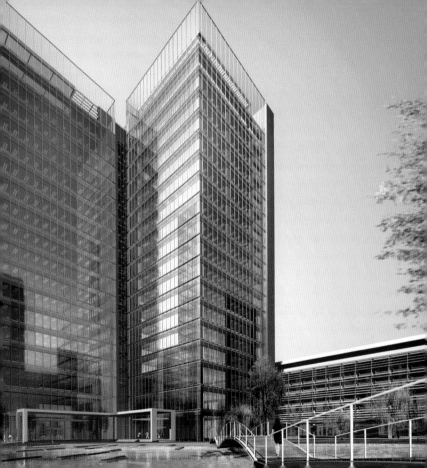

Shanghai
Opera House

Arte Charpentier & Associates

1994
People's Square
Huangpu

www.arte-charpentier.com

The square floor plan of the opera house is a reference to the Chinese symbol for the earth, whereas the sloping roof refers to a circle—the traditional symbol for the sky. The generous glass foyer offers a view of People's Square and the city's impressive backdrop of skyscrapers.

Der quadratische Grundriss des Opernhauses bezieht sich auf das chinesische Symbol für die Erde, während das gebogene Dach auf den Kreis – das traditionelle Symbol für den Himmel – verweist. Das großzügig verglaste Foyer bietet Ausblick auf den People's Square und die beeindruckende Hochhauskulisse der Stadt.

Le plan carré de l'Opéra se réfère au symbole chinois pour la terre, tandis que le toit recourbé rappelle un cercle qui est le symbole chinois traditionnel pour le ciel. Le hall aux multiples vitres offre une vue sur le People's Square et les tours qui forment une coulisse impressionnante dans la ville.

La planta cuadrada de la ópera alude al símbolo chino de la tierra, y su cubierta arqueada, al círculo, la representación tradicional del cielo. El amplio vestíbulo acristalado permite ver la People's Square y el impresionante paisaje de rascacielos de la ciudad.

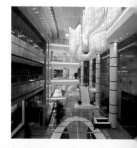

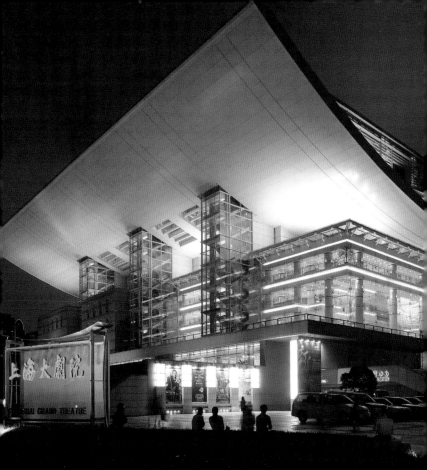

Bund 18 Creative Center

Kokaistudios

2004
18 Zhongshan Dong 1-Lu (The Bund
Huangpu

www.bund18.com
www.kokaistudios.com

The gallery is part of the Bund 18 project. The open floor layout, apart from the massive pillars, makes flexibility and diversity possible when it comes to using the space. A transparent box is sectioned off from the actual exhibition area and is intended as a conference room.

Die Galerie ist Teil des Bund-18-Projektes. Der bis auf die mächtigen Stützen offene Grundriss ermöglicht eine flexible und vielfältige Nutzung des Raumes. Eine transparente Box ist als Besprechungsraum von dem eigentlichen Ausstellungsbereich abgetrennt.

La galerie fait partie du projet Bund 18. Cet espace ouvert, à l'exception des piliers imposants, laisse une grande liberté d'aménagement. Une salle de réunion en forme de box transparent est séparée de la zone prévue pour les expositions.

La galería es parte del proyecto Bund 18. Su planta, abierta hasta sus poderosos pilares, permite un empleo flexible y variado del espacio. Una caja transparente separada de la zona de las exposiciones, sirve como sala de reuniones.

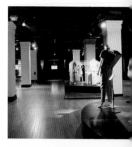

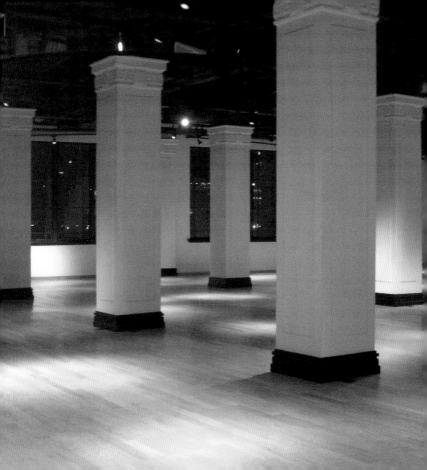

German Consulate Culture Center Goethe-Institut

iaction – Interior Action Ltd.

2002
318 Fu Zhou Lu
Huangpu

www.goethe.de/china

The public library is at the heart of this multi-media information center. A strip of oak runs around the entire room and is used as desk space with work and reading places. The oak strip finally penetrates the external façade and this is how the interior architecture is continued out on the street.

Die öffentliche Bibliothek ist das Herzstück dieses multimedialen Informationszentrums. Ein Band aus Eichenholz zieht sich durch den gesamten Raum und dient als Tresen mit Arbeits- und Leseplätzen. Schließlich durchdringt das Band die Außenfassade und setzt so die Innenarchitektur im Straßenraum fort.

La bibliothèque publique est la pièce maîtresse de ce centre d'information multimédia. Une bande en bois de chêne traverse l'ensemble de l'espace et sert de table pour travailler et lire. Cette bande traverse la façade extérieure et prolonge ainsi l'architecture intérieure dans la zone de la rue.

La biblioteca pública es el corazón de este centro multimediático de información. Una repisa de madera de haya recorre toda la sala y cumple la función de mesa, con sitios para trabajar y leer. Esta franja atraviesa la fachada prolongando de este modo la arquitectura interior en el espacio exterior.

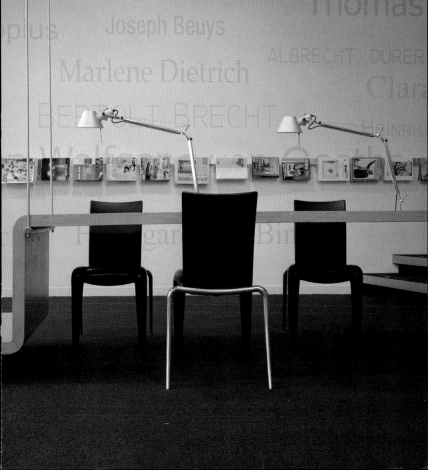

Shanghai Gallery of Art

Michael Graves & Associates

2002
3 Zhongshan Dong 1-Lu (The Bund)
Huangpu

www.threeonthebund.com
www.michaelgraves.com

Space for temporary exhibitions, the gallery's permanent collection as well as a shop selling books and souvenirs extends to over 1200 m². A spectacular, six-storey surrounding atrium also belongs to the gallery.

Auf über 1200 m² Fläche erstrecken sich Räume für temporäre Ausstellungen, die ständige Sammlung der Galerie sowie einen Laden, in dem Bücher und Souveniers verkauft werden. Zur Galerie gehört auch ein spektakuläres, sechs Geschosse umfassendes Atrium.

Les espaces destinés aux expositions temporaires, l'exposition permanente de la galerie ainsi qu'un magasin de souvenirs et de livres recouvrent une surface de plus de 1200 m². La galerie comprend également un vaste atrium spectaculaire de six étages.

Sobre una superficie superior a los 1200 m² se extienden las salas destinadas a las exposiciones temporales y a la colección permanente, además de una tienda donde se venden libros y recuerdos. La galería incluye también un espectacular atrio de seis pisos de altura.

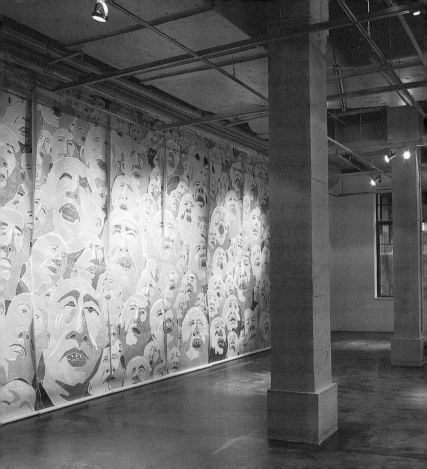

Wall Street English Center

Dedo Design
environetics design group International Inc. (SE)

2002
27 North Block Xintiandi /
159 Madang Lu
Luwan

www.wsi.com.cn
www.edg.com.cn
www.dedodesign.com

Instead of being in the rooms of a language school, you seem to be on board a spaceship here. The reception room with its metal wall cladding could be the command bridge and the comfortable yellow chairs are ready for the passengers.

Statt in den Räumen einer Sprachschule scheint man sich hier eher an Bord eines Raumschiffes zu befinden. Der Empfangsraum mit seiner metallischen Wandverkleidung könnte die Kommandobrücke sein, die bequemen gelben Sessel stehen für die Passagiere bereit.

Cet immeuble ressemble plus à un vaisseau spatial qu'à une école de langues, et la réception avec ses murs aux revêtements métalliques, à une passerelle de commandement. Les fauteuils jaunes paraissent confortables et invitent les passagers à prendre place.

En vez de estar en las salas de una escuela de idiomas, parece como si nos encontrásemos a bordo de una nave espacial. El recibidor, con el revestimiento metálico de sus paredes, podría ser el puente de control, y los cómodos sillones amarillos, parecen estar preparados para los pasajeros.

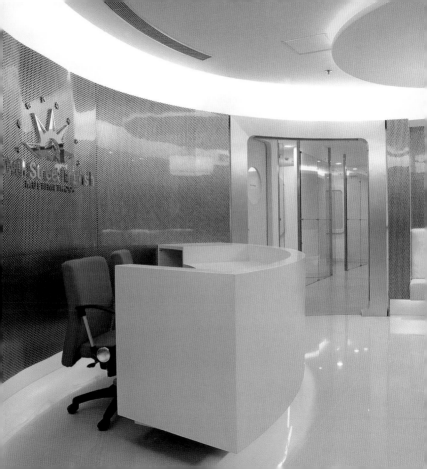

Red Hippo

Cha & Innerhofer Architecture + Design

2005
Nanjing Donglu
Huangpu

www.cha-innerhofer.com

In contrast to the classical and strict methods of Chinese education, in future, the children in this education center can learn in a free and playful way. Stimulating colors and imaginative forms support this teaching concept.

Im Gegensatz zu den klassischen, strengen chinesischen Erziehungsmethoden sollen die Kinder in diesem Schulungszentrum künftig auf freie, spielerische Art lernen können. Anregende Farben und fantasievolle Formen dienen der Unterstützung dieses Unterrichtskonzepts.

Dans cet établissement, les enfants pourront à l'avenir apprendre en jouant, contrairement aux méthodes d'éducation chinoises classiques qui sont sévères. Des couleurs stimulantes et des formes fantaisistes contribuent à renforcer cet enseignement ludique.

Este centro escolar está pensado para que, en el futuro, los niños puedan aprender de una forma libre y lúdica en oposición a los estrictos métodos tradicionales chinos. Los colores llamativos y las imaginativas formas deben servir de apoyo a este concepto de enseñanza.

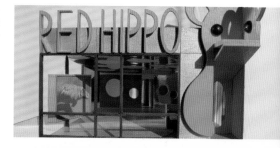

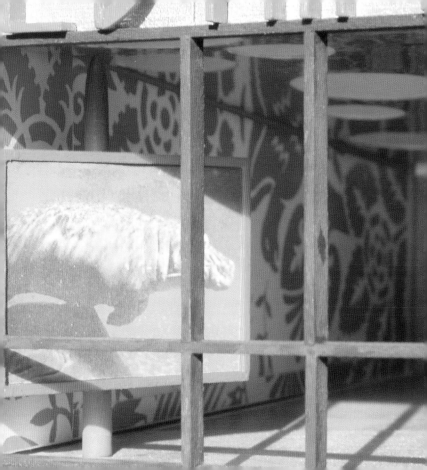

Shanghai
Oriental Art Center

Paul Andreu architecte
East China Architectural Design Institut (ECADI)

2004
Shiji Dadao (Century Avenue)
Pudong

www.paul-andreu.com

The arrangement of the different parts of the building in this cultural center—the entrance hall, concert hall, theater, opera house and exhibition hall—is reminiscent of the petals of an orchid or even like a butterfly. At night, the imposing building is illuminated in all the colors of the rainbow.

Die Anordnung der unterschiedlichen Gebäudeteile des Kulturzentrums – Eingangshalle, Konzertsaal, Theater, Opernhaus und Ausstellungshalle – erinnert an die Blütenblätter einer Orchidee oder auch an einen Schmetterling. Nachts leuchtet der imposante Bau in allen Farben des Regenbogens.

La disposition des différents bâtiments qui composent le centre culturel – hall d'entrée, salle de concert, théâtre, opéra et hall d'exposition – rappelle les pétales de l'orchidée ou encore un papillon. Dans la nuit, cet édifice imposant s'allume dans les couleurs de l'arc-en-ciel.

La ordenación de los diferentes elementos del edificio del centro cultural (vestíbulo, sala de conciertos, teatro, ópera y sala de exposiciones), recuerdan a los pétalos de una orquídea o a una mariposa. Por la noche, este impresionante edificio se ilumina con todos los colores del arco iris.

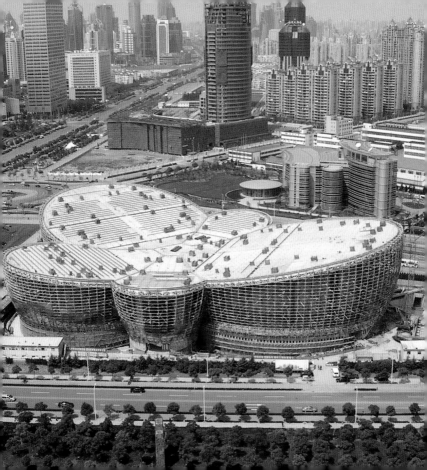

Shanghai Museum of Science & Technology

RTKL Associates Inc.
Ove Arup and Partners (SE)

2001
2000 Shiji Dadao (Century Avenue
Pudong

www.sstm.org.cn
www.rtkl.com
www.arup.com

Different exhibition areas on themes such as intelligence, innovation and future are located beneath a long expanse of roof space that ascends in a spiral shape. The building's overall aspiring figure represents the city's dynamic development.

Unter einem lang gestreckten, spiralförmig ansteigenden Dach befinden sich unterschiedliche Ausstellungsbereiche zu Themen wie Intelligenz, Innovation und Zukunft. Die aufstrebende Gesamtfigur des Gebäudes steht für die dynamische Entwicklung der Stadt.

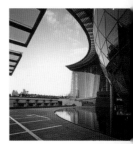

Sous un toit qui monte en forme de spirale se trouvent différentes expositions portant sur des thèmes comme l'intelligence, l'innovation et l'avenir. La silhouette élancée de l'immeuble est à l'image du développement dynamique de la ville.

Debajo de esta cubierta alargada que asciende como una espiral, se alojan las diferentes áreas de la exposición dedicadas a temas como la inteligencia, la innovación y el futuro. La ambiciosa forma del edificio simboliza el dinámico desarrollo de la ciudad.

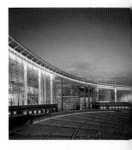

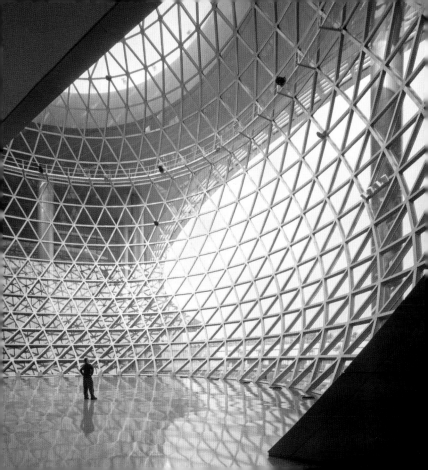

Museum Shanghai-Pudong

gmp Architekten – von Gerkan, Marg und Partner

2005
520 Yingchun Lu
Pudong

www.gmp-architekten.de

Simplicity and reduction define the new museum building where, in future, exhibitions will inform the public about the history and future of Pudong. The glass façades of the building's upper level are printed with pictures from the museum's collection or serve as projection surfaces for multi-media presentations.

Einfachheit und Reduktion bestimmen den neuen Museumsbau, in dem künftig Ausstellungen über Geschichte und Zukunft von Pudong informieren werden. Die Glasfassaden der oberen Gebäudeebene sind mit Bildern aus der Sammlung des Museums bedruckt oder dienen als Projektionsflächen für multimediale Präsentationen.

La simplicité et la sobriété déterminent la construction du nouveau musée où des expositions informeront à l'avenir sur l'histoire et le futur de Pudong. Les façades vitrées en haut du bâtiment sont recouvertes des images des tableaux de la collection du musée ou servent de surface de projection pour des présentations multimédias.

La sencillez y la reducción caracterizan el nuevo edificio del museo, que en el futuro albergará exposiciones sobre la historia y el futuro de Pudong. Las fachadas acristaladas de la planta superior del edificio están estampadas con cuadros de la exposición del museo o sirven como superficie de proyección para presentaciones multimedia.

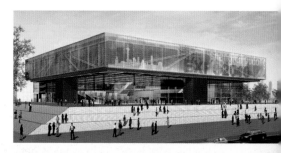

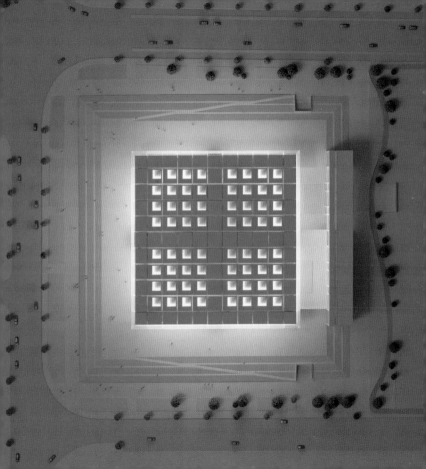

H-Space

Shanghart Gallery

2004
50 Moganshan Lu
Putuo

www.shanghart.com

Shanghart Gallery, one of the city's most interesting art galleries, shows radical works by young artists from all over China. Several old industrial buildings were renovated for this purpose with relatively modest funds and transformed into unusual exhibition venues.

Shanghart Gallery, eine der interessantesten Kunstgalerien der Stadt, zeigt radikale Arbeiten junger Künstler aus ganz China. Mehrere alte Industriegebäude wurden dazu mit einfachen Mitteln renoviert und in ungewöhnliche Ausstellungsorte verwandelt.

La Shanghart Gallery, l'une des galeries d'art les plus intéressantes de la ville, présente des travaux radicaux réalisés par des jeunes artistes de toute la Chine. Plusieurs bâtiments d'usine ont été restaurés avec de simples moyens et transformés en des lieux d'exposition originaux.

La Shanghart Gallery, una de las galerías de arte más interesantes de la ciudad, muestra los trabajos radicales de jóvenes artistas de toda China. Empleando sencillos materiales, varios edificios industriales antiguos fueron saneados y transformados en insólitas salas de exposiciones.

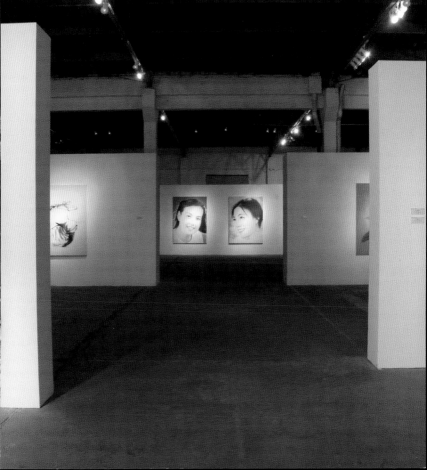

Shanghai American School

B+H Architects – Bregman + Hamann

1998
258 Jinfeng Lu
Minhang

www.bharchitects.com

The school is designed as a group of pavilions in a rurally structured environment. The different age groups—kindergarten, junior and high school—are accommodated as separate units in their own pavilions. In addition, the campus also has a sports hall, swimming pool and auditorium for an audience of 800.

Die Schule ist als eine Gruppe von Pavillons in einer landschaftlich gestalteten Umgebung konzipiert. Die unterschiedlichen Altersstufen – Kindergarten, Mittel- und Oberschule – sind als Einheiten in jeweils eigenen Pavillons untergebracht. Zur Anlage gehören außerdem eine Sporthalle, ein Schwimmbad und ein Auditorium für 800 Zuhörer.

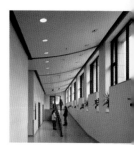

L'école a été conçue comme un ensemble de pavillons dans un environnement qui ressemble à un paysage. Les différentes classes d'âge – maternelle, école primaire et secondaire – constituent des unités séparées ayant chacune un pavillon. Ce complexe comprend en outre une salle de sports, une piscine et un auditorium pour 800 auditeurs.

La escuela fue concebida como un grupo de pabellones edificados en un entorno inspirado en el ambiente rural. Los diferentes ciclos escolares, jardín de infancia, enseñanza media y enseñanza superior, se alojan en diferentes pabellones individuales. La instalación incluye, además, un gimnasio, una piscina y un auditorio para 800 personas.

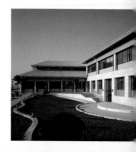

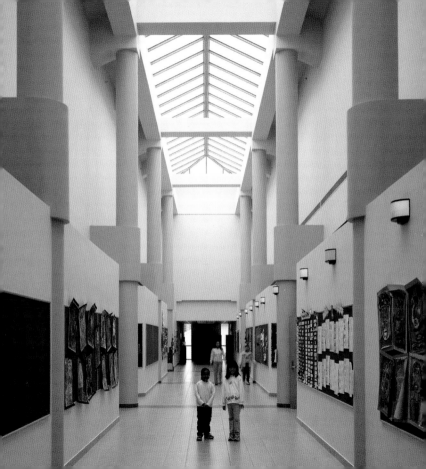

South African Consulate General

iaction – Interior Action Ltd.

2003
222 Yan'an Donglu
Huangpu

www.dfa.gov.za/foreign

The circular canopy in the reception area of the South African Consulate is reminiscent of the straw roof of a traditional African hut. The design of the reception desk for issuing visas is supposed to reflect the diversity of the country and its inhabitants and in that way have an inviting appeal for future visitors.

Der kreisrunde Deckenschirm im Empfang des südafrikanischen Konsulats erinnert an das Strohdach einer traditionellen afrikanischen Hütte. Die Gestaltung des Schalterbereichs zur Ausgabe der Visa soll die Vielfalt des Landes und seiner Bewohner widerspiegeln und damit einladend auf künftige Besucher wirken.

Le parasol qui décore le plafond dans l'entrée du consulat d'Afrique du Sud rappelle le toit de chaume d'une hutte africaine traditionnelle. L'aménagement de la zone des guichets où sont délivrés les visas vise à représenter la diversité du pays et de ses habitants et à donner aux visiteurs l'envie de venir découvrir l'Afrique du Sud.

La pantalla circular de la cubierta de la entrada del consulado sudafricano, recrea el tejado de paja de las cabañas tradicionales africanas. El diseño de la zona de las ventanillas donde se entregan los visados, quiere reflejar la diversidad del país y de sus habitantes y atraer, de este modo, a futuros visitantes.

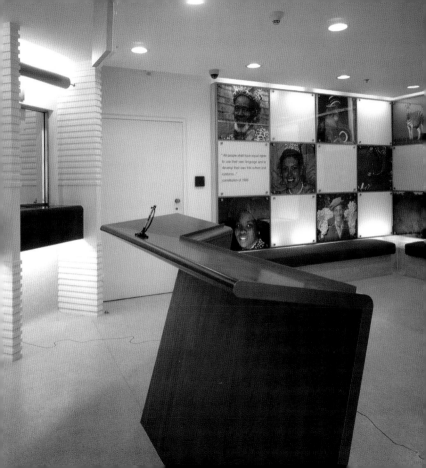

Century Avenue

Arte Charpentier & Associates, TUP Landscaper, EPAD

2000
Shiji Dadao (Century Avenue)
Pudong

www.arte-charpentier.com

The five-kilometer stretch of Century Avenue is the most important traffic intersection and cuts right across the new commercial and financial district of Pudong. Themed gardens are located at regular intervals along the avenue and their protection from traffic noise makes them places of peace and relaxation.

Die fünf Kilometer lange Century Avenue durchquert als wichtigste Verkehrsachse das neue Geschäfts- und Finanzviertel Pudong. Entlang der Straße liegen in regelmäßigen Abständen vom Verkehrslärm geschützte Themengärten als Orte der Ruhe und Erholung.

La Century Avenue longue de cinq kilomètres est l'axe routier le plus important qui traverse le nouveau quartier des affaires et des finances de Pudong. A intervalles réguliers, des jardins thématiques, protégés contre le bruit de la circulation, jalonnent cette route comme des oasis de paix et de repos.

La Century Avenue, de cinco kilómetros de longitud, es el eje de circulación más importante de la ciudad y, como tal, atraviesa el nuevo barrio comercial y financiero de Pudong. A lo largo de esta calle, y dispuestos a distancias regulares, se encuentran, protegidos del ruido del tráfico, los jardines temáticos, lugares para la tranquilidad y el descanso.

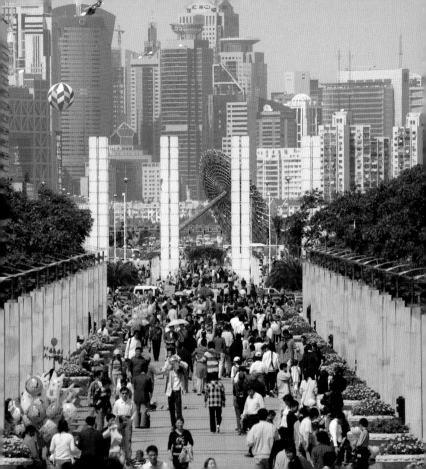

Century Plaza

Arte Charpentier & Associates, TUP Landscaper, EPAD

1996
Shiji Dadao (Century Avenue)
Pudong

www.arte-charpentier.com

The Plaza is located at the southern end of Century Avenue and provides a transition from the traffic intersection and Century Park. Beneath the Plaza there are several lower-ground levels where a subway station, shopping center and parking lot are located.

Die Plaza liegt am Südende der Century Avenue und formuliert den Übergang zwischen der Verkehrsachse und dem Century Park. Unter dem Platz befinden sich in mehreren Tiefgeschossen eine U-Bahn-Station sowie ein Einkaufszentrum und ein Parkhaus.

La Plaza se trouve au bout de la Century Avenue au sud et fait le lien entre l'axe routier et le Century Park. Sur plusieurs étages souterrains sous cette place, se trouvent une station de métro, un centre commercial et un parking.

El Plaza se levanta en el extremo sur de la Century Avenue y actúa como puente entre el eje de circulación y el Century Park. Debajo de la plaza hay varios niveles que acogen una estación de metro, un centro comercial y un aparcamiento.

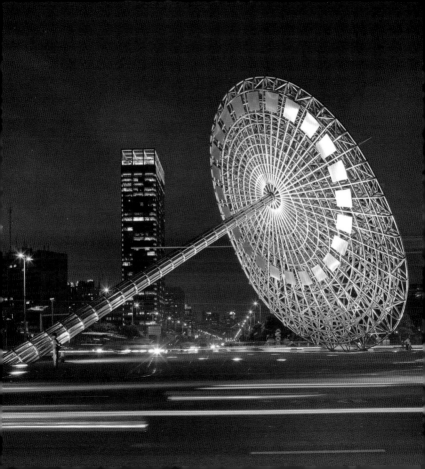

Century Park

Land Use Consultants (LUC)
Jestico + Whiles

2000
Shiji Dadao (Century Avenue)
Pudong

www.landuse.co.uk
www.jesticowhiles.co.uk

Shanghai's largest ecological city park covers an area of over 140 ha. The park's site was designed by landscape architects LUC Landuse, the design for the entrance pavilions with the rolling sun canopies is by architects Jestico + Whiles.

Der größte ökologische Stadtpark in Shanghai umfasst eine Fläche von über 140 ha. Die Parkanlage wurde von den Landschaftsarchitekten LUC Landuse gestaltet, der Entwurf der Eingangspavillons mit den geschwungenen Schattendächern stammt von den Architekten Jestico + Whiles.

Le plus grand parc écologique de Shanghai recouvre une surface de plus de 140 ha. Il a été aménagé par le paysagiste LUC Landuse. Les pavillons d'entrée avec leurs avant-toits recourbés ont été conçus par les architectes Jestico + Whiles.

El mayor parque ecológico de la ciudad de Shanghai tiene una extensión superior a las 140 hectáreas. El parque fue diseñado por los arquitectos paisajistas LUC Landuse, mientras que el proyecto del pabellón de entrada, con sus marquesinas arqueadas, es obra de los arquitectos Jestico + Whiles.

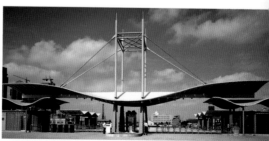

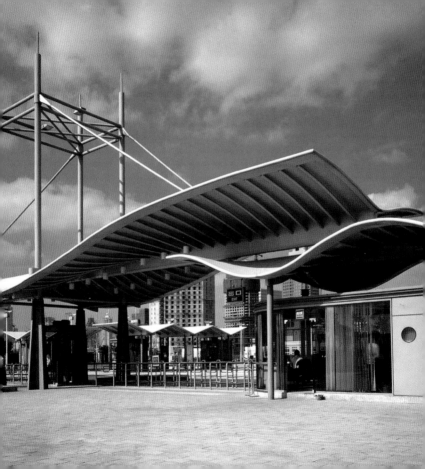

Shanghai New International Expo Center

Murphy/Jahn, Shanghai Modern Architectural Design Group
Werner Sobek Ingenieure (SE)

2001
2345 Longyang Lu
Pudong

www.sniec.net/e
www.murphyjahn.com

The Shanghai New International Expo Center is considered the most modern and efficient exhibition location in eastern Asia. The exhibition halls, each 68 x 164 m, are arranged around a central open-plan area. When the site is completed, the exhibition space of all the halls should reach over 200.000 m².

Das Shanghai New International Expo Center gilt als das modernste und leistungsfähigste Messegelände in Ostasien. Die jeweils 68 x 164 m großen Hallen ordnen sich um einen zentralen Freibereich. Im Endausbau des Geländes soll die Ausstellungsfläche aller Hallen zusammen über 200.000 m² umfassen.

Le Shanghai New Internation Expo Center a la réputatio d'être le parc d'expositions plus moderne et le plus perfo mant d'Asie de l'Est. Les gra des halles de 68 x 164 m chac ne s'agencent autour d'une zor centrale dégagée. Quand les cons tructions seront terminées, surface de toutes les halles d'ex position dépassera 200 000 m²

El Shanghai New International Expo Center es el recinto ferial más moderno y amplio de Asia Oriental. Los pabellones, con un tamaño de 68 x 164 m cada uno, están dispuestos alrededor de una zona al aire libre. Cuando se concluya la construcción del recinto, la superficie de todos los pabellones juntos será superior a los 200.000 m².

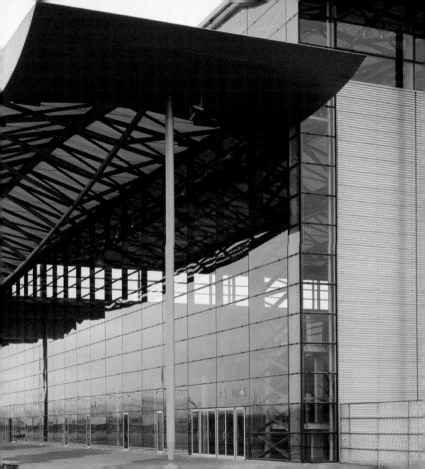

Xujiahui Park

WAA international Ltd. – Williams,
Asseline, Ackaoui et associés, inc.

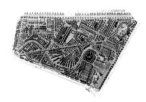

2002
Hengshan Lu / Wanping Lu
Xuhui

www.waa-ap.com

The concept relies on an overlap between Shanghai's city planning and the layout of the park. Particular places inside the park can then be thematically linked with special locations in the city. A wide-spanning pedestrian bridge gives an overview over the entire site.

Das Konzept beruht auf der Überlagerung des Stadtplans von Shanghai mit dem Grundriss des Parks. Bestimmte Stellen innerhalb des Parks werden so thematisch mit besonderen Orten der Stadt verbunden. Eine weit gespannte Fußgängerbrücke ermöglicht den Überblick über die Gesamtanlage.

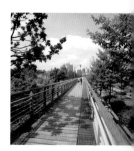

Le concept vise à transposer le plan de la ville de Shanghai dans le parc. Certains endroits du parc et de la ville ont ainsi des correspondances thématiques. Sur la grande passerelle, les piétons ont une vue d'ensemble du parc.

El concepto está basado en la superposición del plano de la ciudad de Shanghai sobre la planta del parque. De este modo, determinadas zonas del parque están unidas temáticamente con diferentes lugares de la ciudad. Un largo puente peatonal permite ver toda la instalación.

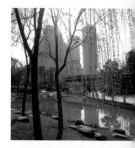

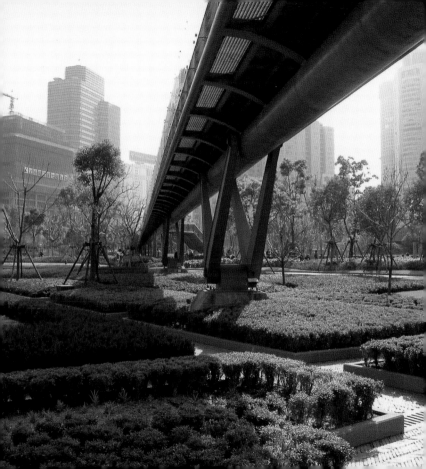

Consulate General of Switzerland

iaction – Interior Action Ltd.

2002
319 Xianxia Lu
Changning

The Swiss flag itself is turned into a design feature in these rooms and refers to the meaning and function of the Consulate. The selection of materials symbolizes the country's typical features: for example, glass wall claddings are to evoke associations with glaciers.

Die Schweizer Flagge selbst wird in diesen Räumen zum Gestaltungselement und verweist auf die Bedeutung und Funktion des Konsulats. Die Auswahl der Materialien symbolisiert typische Merkmale des Landes: Beispielsweise sollen gläserne Wandverkleidungen Assoziationen an Gletscher wecken.

Le drapeau suisse joue également un rôle dans l'aménagement des lieux. Il souligne l'importance et la fonction du consulat. Le choix des matériaux symbolise les caractéristiques du pays. Les revêtements muraux en verre rappellent par exemple les glaciers en Suisse.

La propia bandera de Suiza actúa como un elemento integrado en el diseño de estos espacios, y alude al significado y a la función del consulado. La selección de los materiales son símbolo de las típicas características del país: p.ej., los revestimientos acristalados de las paredes son una representación de los glaciales.

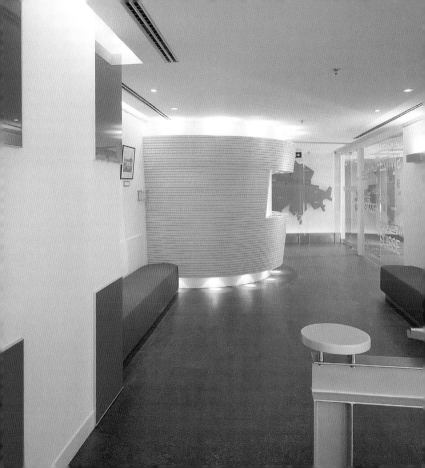

Qushui Garden

MADA s.p.a.m.
Su Zhou Garden Design Institute (SE)

2004
Gongyuan Lu
Qingpu

www.madaspam.com

Historic and modern architectural elements are rarely linked so radically with each other as they are here. An expressively folded, exposed concrete wall forms the extension of a traditional colonnade. The new concrete roof covers the old wood construction—a symbolic expression of the connection of old and new.

Selten werden historische und moderne Architekturelemente so radikal miteinander verbunden wie hier. Eine expressiv gefaltete Sichtbetonwand bildet die Verlängerung eines traditionellen Wandelganges. Das neue Betondach führt über die alte Holzkonstruktion hinweg – ein symbolischer Ausdruck der Verbindung von Alt und Neu.

Il est rare que des éléments d'architecture historiques et modernes soient associés de manière aussi radicale qu'ici. Un mur de béton aux plis expressifs apparent prolonge le promenoir traditionnel. Le nouveau toit en béton dépasse l'ancienne construction en bois et exprime symboliquement le lien qui existe entre l'ancien et le nouveau.

Pocas veces se han unido de una forma tan radical los elementos arquitectónicos modernos con los históricos. Una pared de hormigón visto, expresivamente plegada, representa una prolongación del tradicional camino de peregrinación. La nueva cubierta de hormigón continúa sobre la antigua construcción de madera, una expresión simbólica de la unión entre lo nuevo y lo viejo.

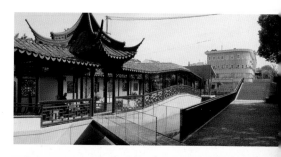

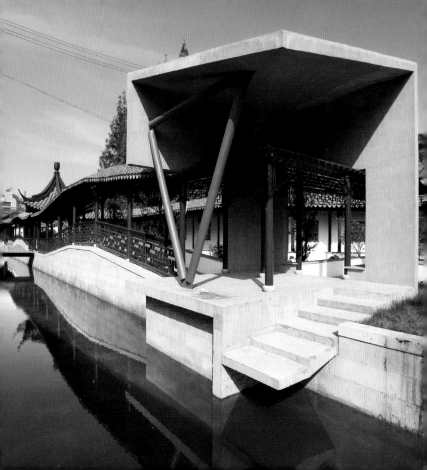

to stay . hotels

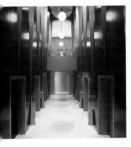
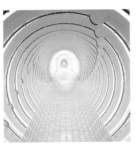
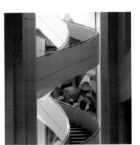
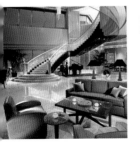
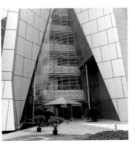
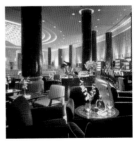

The Westin Shanghai Bund Center

John Portman & Associates

2002
88 Henan Zhonglu
Huangpu

www.bundcenter.com
www.starwood.com/westin
www.portmanusa.com

The Westin Hotel is located inside the Bund Center. The "crown" of the building is supposed to be a reminder of a lotus flower—the traditional Chinese symbol for growth and prosperity. This crown begins to light up in the evening and is widely visible across Shanghai's night skyline.

Das Westin Hotel befindet sich innerhalb des Bund Centers. Die „Krone" des Gebäudes soll an eine Lotosblüte erinnern – das traditionelle chinesische Symbol für Wachstum und Wohlstand. Am Abend beginnt diese Krone zu leuchten und strahlt weithin sichtbar über die nächtliche Skyline von Shanghai.

L'hôtel Westin est à l'intérieur du Bund Center. La « couronne » du bâtiment ressemble à une fleur de lotus qui est le symbole chinois traditionnel pour l'expansion et la prospérité. Le soir, cette couronne s'illumine et est reconnaissable de loin dans la skyline nocturne de Shanghai.

El hotel Westin se encuentra dentro del Bund Center. La "corona" del edificio evoca una flor de loto, el símbolo tradicional chino del crecimiento y el bienestar. Por la tarde, esta corona se ilumina y la luz que irradia puede verse en el cielo nocturno de la silueta de Shanghai.

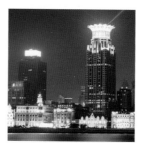
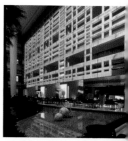

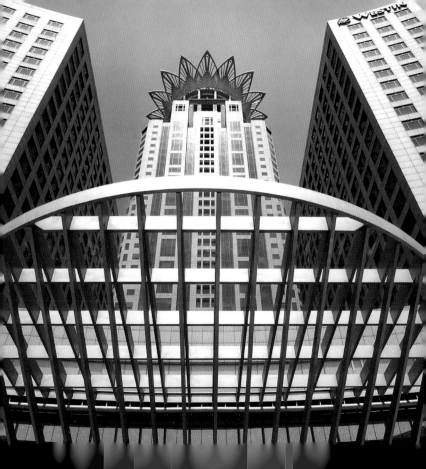

Marriott Hotel
Tomorrow Square

John Portman & Associates

2002
399 Nanjing Xilu
Huangpu

www.marriott.com
www.portmanusa.com

The skyscraper's layout is based on two squares, which are rotated by 45 degrees against each other, at 37th floor level. The function in the interior of the tower also changes accordingly: the actual hotel is located in the upper section and apartments for longer stays are for rent in the lower section.

Der Grundriss des Hochhauses beruht auf zwei Quadraten, die auf Höhe des 37. Stockwerks um 45 Grad gegeneinander verdreht sind. Entsprechend wechselt auch die Funktion im Inneren des Turms: Im oberen Abschnitt liegt das eigentliche Hotel, im unteren Teil werden Apartments für längere Aufenthalte vermietet.

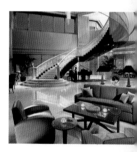

Le plan de l'immeuble est basé sur deux carrés qui, au 37e étage, se tournent à 45 degrés. A ce changement extérieur correspond un changement intérieur : l'hôtel occupe la partie supérieure, et les appartements pour hôtes en long séjour, la partie inférieure.

La planta de este rascacielos descansa sobre dos cuadrados que, a la altura de la planta 37, giran 45 grados en sentidos opuestos. De forma análoga cambia también la función del espacio interior de la torre: en la parte superior se encuentra el hotel mientras que, en la inferior, hay apartamentos que se alquilan por largos periodos de tiempo.

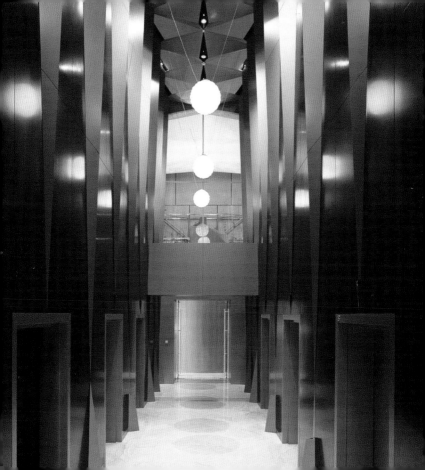

Four Seasons Hotel Shanghai

HOK International (Asia Pacific) Ltd.

2002
500 Wei Hai Lu
Jingan

www.fourseasons.com

In addition to about 440 rooms, the Four Seasons Hotel offers its guests a luxurious environment. This includes the impressive lobby-lounge, a jazz club on the 37th floor and an exclusive spa with a 20-meter pool.

Das Four Seasons Hotel bietet seinen Gästen neben den knapp 440 Zimmern ein luxuriöses Umfeld. Dazu zählen die eindrucksvolle Lobby-Lounge, ein Jazz Club im 37. Stockwerk und ein exklusives Spa mit einem 20-Meter-Schwimmbecken.

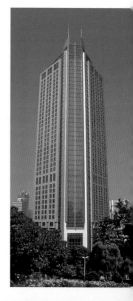

L'hôtel Four Seasons compte près de 440 chambres et offre un environnement luxueux à ses hôtes, notamment une lobby-lounge impressionnante, un club de jazz au 37e étage et un spa exclusif avec une piscine de 20 mètres.

El hotel Four Seasons ofrece a sus huéspedes casi 440 habitaciones además de un lujoso ambiente, un impresionante vestíbulo con salón, un club de jazz en el piso 37 y un exclusivo spa con una piscina de 20 metros.

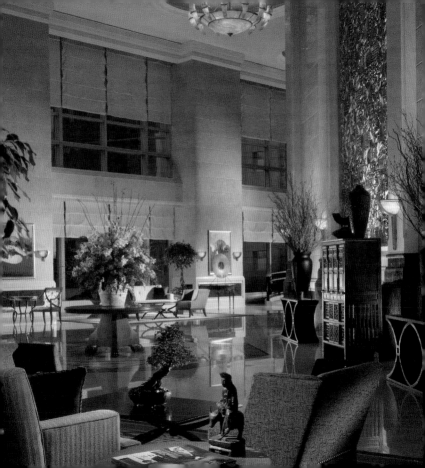

The Portman Ritz Carlton Shanghai Center

John Portman & Associates

1992
1376 Nanjing Xilu
Jingan

www.ritzcarlton.com
www.shanghaicentre.com
www.portmanusa.com

The 48-storey Portman Ritz-Carlton Hotel is located in the middle of the Shanghai Center and is flanked by two other towers with apartments and living quarters. A spacious atrium as well as shops, restaurants, bars and a theater with space for 1000 are all located in the lower floors of the building complex.

Im Zentrum des Shanghai Centers steht das 48-geschossige Portman Ritz-Carlton Hotel, flankiert von zwei weiteren Türmen mit Apartments und Wohnungen. Im Sockelbereich des Gebäudekomplexes befinden sich ein großzügiges Atrium sowie Läden, Restaurants, Bars und ein Theater für 1000 Zuschauer.

L'hôtel Portman Ritz-Carlton est situé au cœur du Shanghai Center et compte 48 étages. Il est flanqué de deux tours qui abritent des appartements et des studios. Dans la partie inférieure de l'édifice se trouvent un atrium spacieux ainsi que des magasins, des restaurants, des bars et un théâtre pouvant accueillir 1000 spectateurs.

En el centro del Shanghai Center se alza el hotel Portman Ritz-Carlton, de 48 plantas, flanqueado por otras dos torres de apartamentos y viviendas. La zona del zócalo del edificio alberga un amplio atrio, tiendas, restaurantes, bares y un teatro para 1000 espectadores.

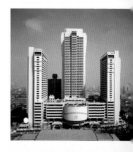

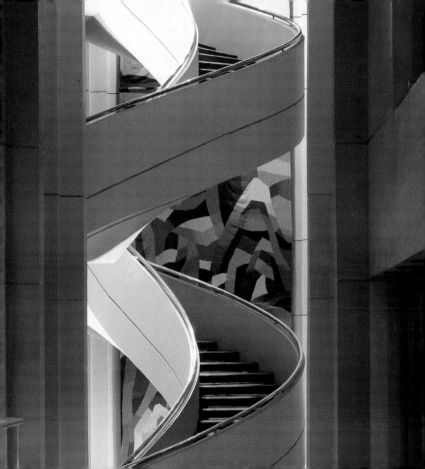

Grand Hyatt Shanghai
Jin Mao Tower

Skidmore, Owings & Merrill LLP, Bilkey Llinas Consulting

1999
88 Shiji Dadao (Century Avenue)
Pudong

www.shanghai.grand.hyatt.com
www.som.com
www.bilkeyllinas.com

The Grand Hyatt Shanghai is located between floors 53 and 87 of the Jin Mao Tower. An enormous, central atrium connects the hotel's 35 floors and creates one of the city's most spectacular interior spaces.

Das Grand Hyatt Shanghai befindet sich zwischen dem 53. und 87. Stockwerk des Jin Mao Towers. Ein riesiges, zentrales Atrium verbindet die 35 Hotelgeschosse und schafft damit einen der spektakulärsten Innenräume der Stadt.

Le Grand Hyatt Shanghai s trouve entre le 53e et le 87e éta ge de la tour Jin Mao. Un atriu immense relie au milieu les 3 étages de l'hôtel. C'est l'un de espaces intérieurs les plus spe taculaires de la ville.

El Grand Hyatt Shanghai está situado entre las plantas 53 y 87 de la Jin Mao Tower. Un enorme atrio central une las 35 plantas del hotel, creando uno de los espacios interiores más espectaculares de la ciudad.

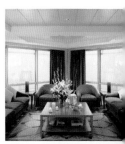

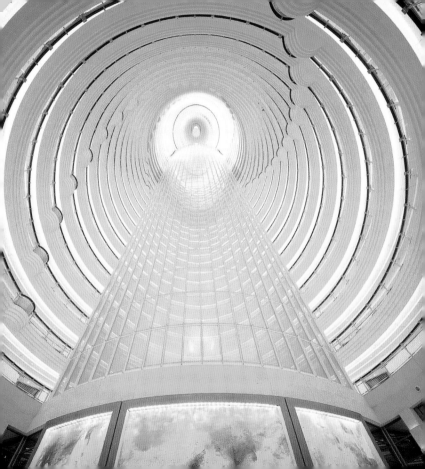

St Regis Hotel Shanghai

Sydness Architects, PC
East China Architectural Design Institut (ECADI)
Leslie E. Robertson Associates (SE)

2001
889 Dong Fang Lu
Pudong

www.starwoodhotels.com/stregis
www.sydnessarchitects.com
www.lera.com

The skyscraper is split into two building sections, in which the hotel's approx. 320 rooms are located. The city's largest hotel rooms are at the St Regis, with rooms sized at 48 m². An intervening glass section links the two parts of the building.

Das Hochhaus ist in zwei Gebäudescheiben gegliedert, in denen sich die knapp 320 Zimmer des Hotels befinden. Mit 48 m² verfügt das St. Regis über die größten Hotelzimmer der Stadt. Ein gläserner Zwischentrakt verbindet die beiden Gebäudeteile.

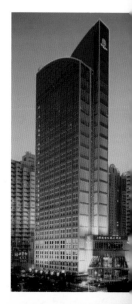

L'immeuble est composé de deux bâtiments abritant les 320 chambres de l'hôtel. Avec une surface de 48 m², c'est le St. Regis qui a les plus grandes chambres d'hôtel de la ville. Les deux parties du bâtiment sont reliées par un passage vitré.

El cuerpo del rascacielos está dividido en dos secciones longitudinales que albergan las casi 320 habitaciones del hotel. St. Regis posee la habitación más grande de hotel de la ciudad, de 48 m². Un ala acristalada une ambas partes del hotel.

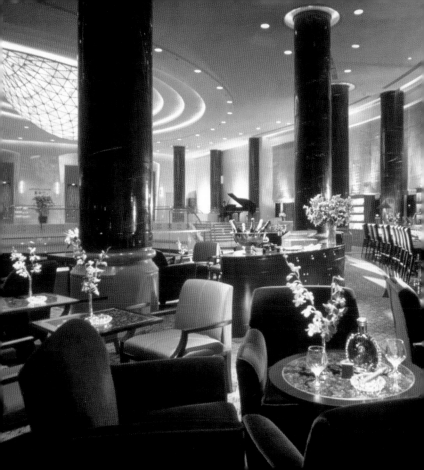

Shanghai Regent Hotel

Arquitectonica

2005
1088 Yan'an Xilu
Changning

www.arquitectonica.com

Even in Shanghai, this tower is eye-catching: the three sections end at different levels and give the building a dynamic, almost unstable look. The façades are also structured in different colored glass and metal panels.

Dieser Turm fällt selbst in Shanghai auf: Die drei Abschnitte enden jeweils in schiefen Ebenen und verleihen dem Gebäude einen dynamischen, beinahe instabilen Ausdruck. Die Fassaden sind zusätzlich durch verschiedenfarbige Glas- und Metallpaneele gegliedert.

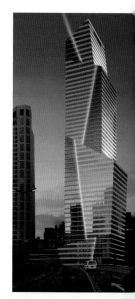

Même à Shanghai, cette tour ne passe pas inaperçue : les trois sections se terminent chacune de manière oblique et confèrent au bâtiment une expression dynamique et presque instable. Des plaques vitrées et métalliques de différentes couleurs structurent en outre les façades.

Esta torre llama la atención incluso en Shanghai: Las tres secciones acaban en un plano inclinado confiriendo al edificio un aspecto dinámico y casi inestable. Las fachadas están divididas también por los paneles de vidrio y metálicos en diferentes colores.

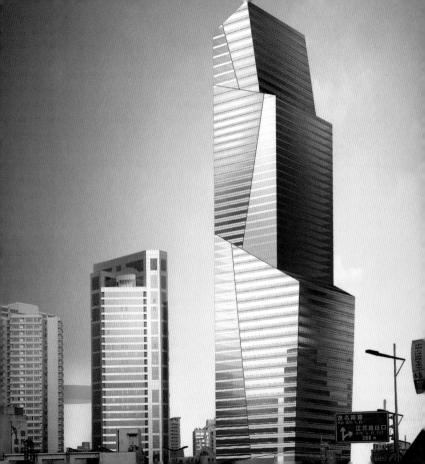

to go . eating
drinking
clubbing
wellness, beauty & sport

 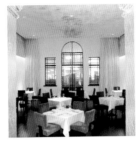 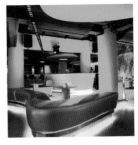

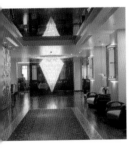 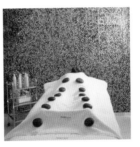 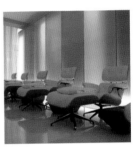

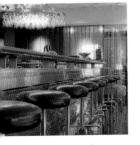

Cupola

Michael Graves & Associates

2004
3 Zhongshan Dong 1-Lu (The Bund)
Huangpu

www.threeonthebund.com
www.michaelgraves.com

This is sure to be one of Shanghai's most exclusive places: just about eight people can be served on the lower level of the former bell-tower. The 8 m high room at the top of the tower is reserved for romantic dinners with only two guests.

Sicher einer der exklusivsten Orte in ganz Shanghai: Auf der unteren Ebene des ehemaligen Glockenturms können gerade einmal acht Personen bewirtet werden. Der 8 m hohe Raum in der Turmspitze bleibt intimen Diners von nur zwei Gästen vorbehalten.

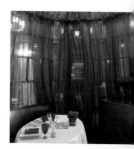

C'est certainement l'un des endroits les plus exclusifs de Shanghai. Dans la partie inférieure de l'ancien clocher, il y a seulement de la place pour tout juste huit personnes. La salle haute de 8 m, dans la partie supérieure du clocher, est réservée aux dîners en tête-à-tête dans l'intimité.

Seguramente este sea uno de los lugares más exclusivos de Shanghai: En la planta baja del antiguo campanario sólo es posible atender a ocho personas, mientras que el espacio de la parte superior del campanario, de 8 m de altura, se reserva siempre para una comida privada de sólo dos huéspedes.

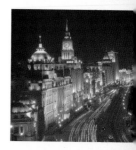

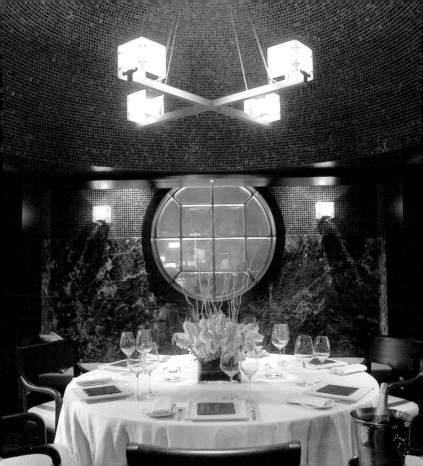

Kathleen's 5 Rooftop Restaurant & Bar

China Union, Liu Dong
Spencer and Robinson (SE)

2004
325 Nanjing Xilu
Huangpu

www.kathleens5.com.cn

Kathleen's 5 is located in the attic storey of Shanghai Art Museum. The modern extensions—the "Glass Atrium", the elegant "Orange Room" and the spectacular "Terrace Bar"—are an exciting contrast to the neo-classical architecture of the museum.

Kathleen's 5 befindet sich im Dachgeschoss des Shanghai Art Museum. Die modernen Aufbauten – das „Glass Atrium", der elegante „Orange Room" und die spektakuläre „Terrace Bar" – stehen in einem spannenden Kontrast zu der neoklassizistischen Architektur des Museums.

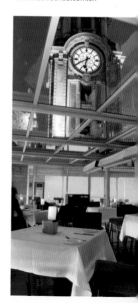

Kathleen's 5 se trouve dans les combles du Shanghai Art Museum. Les ajouts modernes – le « Glass Atrium », l'élégant « Orange Room » et la spectaculaire « Terrace Bar » – offrent un contraste marqué avec l'architecture néoclassique du musée.

Kathleen's 5 se encuentra en el ático del museo Shanghai Art. Sus modernas construcciones, el "atrio de cristal", el elegante "orange room" y la espectacular "terrace bar", establecen un interesante contraste con la arquitectura neoclásica del museo.

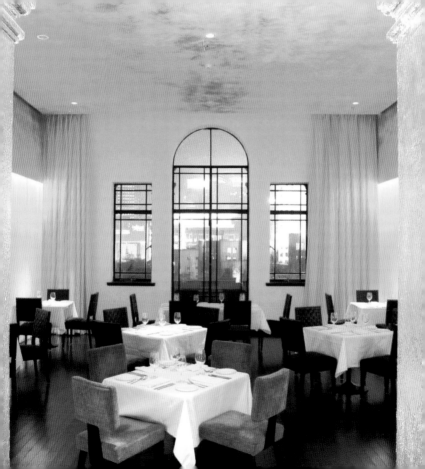

Laris

Michael Graves & Associates

2004
3 Zhongshan Dong 1-Lu (The Bund),
Huangpu

www.threeonthebund.com
www.michaelgraves.com

The different rooms in the restaurant have a light and cheerful atmosphere due to the carefully coordinated mixture of light and material colors. The walls and ceiling of a dining room for special occasions are completely covered in mirrors made of precious gold frames.

Eine sorgfältig abgestimmte Mischung der Licht- und Materialfarben verleiht den verschiedenen Räumen des Restaurants eine leichte und heitere Grundstimmung. Die Wände und Decke eines Speisezimmers für besondere Anlässe sind vollständig mit Spiegeln in kostbaren goldenen Rahmen verkleidet.

Un jeu de lumières et de matériaux colorés soigneusement assortis confère aux différentes salles du restaurant une atmosphère de légèreté et de gaieté. Les murs et le plafond d'une salle pour les grandes occasions sont entièrement habillés de précieux miroirs dans des cadres dorés.

La cuidadosa mezcla de los colores de la luz y de los materiales confiere a los diferentes espacios del restaurante un ambiente ligero y divertido. Las paredes y el techo de uno de los comedores, destinado a ocasiones especiales, están totalmente revestidos con espejos enmarcados en oro.

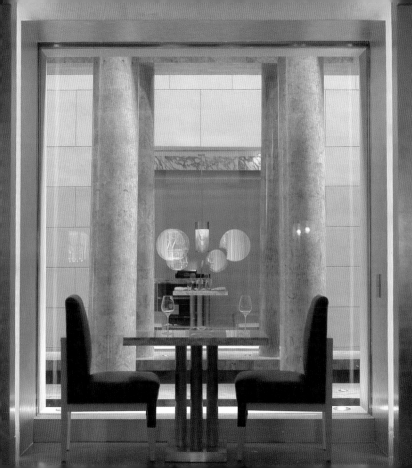

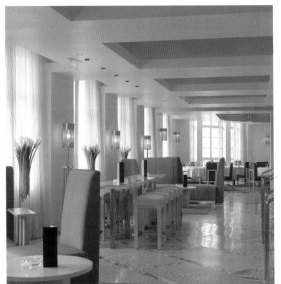

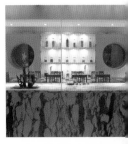

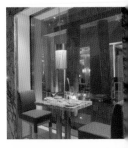

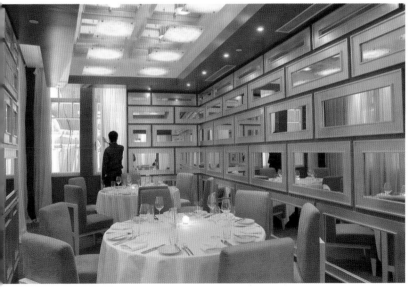

M on the Bund

Hassel Ltd., Dialogue Ltd., Collaborate Ltd.

1999
5 Zhongshan Dong 1-Lu (The Bund)
Huangpu

www.m-onthebund.com

The bar and restaurant are located directly on the "Bund", in the seventh floor of a former shipping company dating back to 1925. Panoramic windows and a roof terrace give unique views over Huang-Pu river and Pudong's skyscrapers.

Bar und Restaurant liegen direkt am Bund, im 7. Geschoss eines ehemaligen Reedereigebäudes aus dem Jahr 1925. Panoramafenster und Dachterrasse bieten einzigartige Blicke über den Huang-Pu-Fluss auf die Hochhäuser von Pudong.

Le bar et le restaurant sont situés directement près du Bund, au 7e étage d'un ancien bâtiment d'armateur construit en 1925. Les fenêtres panoramiques et le toit-terrasse offrent une vue unique sur les tours du Pudong au-delà du fleuve Huang-Pu.

El bar y el restaurante se encuentran directamente en el Bund, en la séptima planta de un antiguo edificio del año 1925 perteneciente a una compañía naviera. Las ventanas panorámicas y la terraza del tejado ofrecen una vista excepcional sobre el río Huang-Pu y los rascacielos de Pudong.

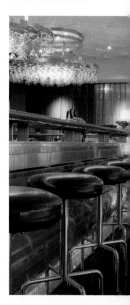

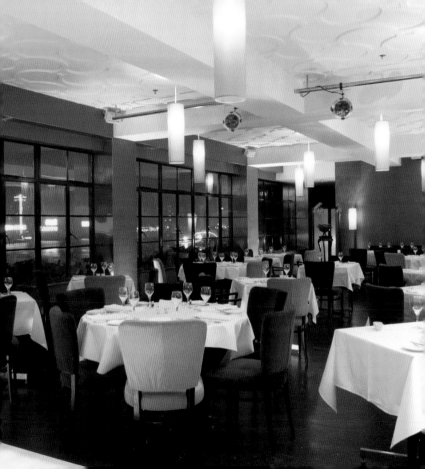

Tan Wai Lou

Kokaistudios

2004
18 Zhongshan Dong 1-Lu (The Bund
Huangpu

www.kokaistudios.com

The Venetian architect who was responsible for the Bund 18 renovation project also designed this Chinese restaurant. Here, European and Chinese style elements are integrated to form a fascinating spatial impression.

Der venezianische Architekt, der für die Renovierung des Bund-18-Projektes verantwortlich war, hat auch dieses chinesische Restaurant gestaltet. Europäische und chinesische Stilelemente verbinden sich hier zu einem faszinierenden Raumeindruck.

L'architecte vénitien qui était chargé de la rénovation du projet Bund 18 a également aménagé ce restaurant chinois. Le mélange d'éléments de style européen et chinois rend cet espace fascinant.

El arquitecto veneciano responsable del saneamiento del proyecto Bund 18, fue también el diseñador de este restaurante chino. Elementos estilísticos europeos y chinos se unen consiguiendo un fascinante efecto.

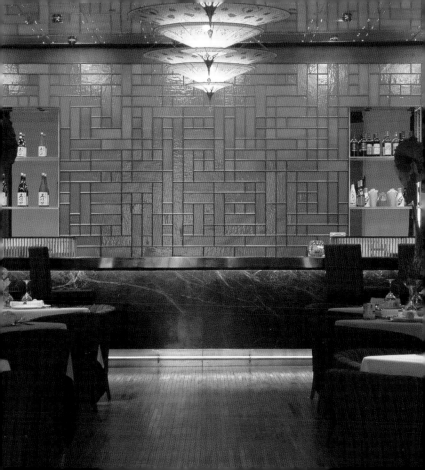

Whampoa Club

Alan Chan Design

3 Zhongshan Dong 1-Lu (The Bund)
Huangpu

www.threeonthebund.com
www.alanchandesign.com

The design of the club on the 5th floor of the "Three on the Bund" building is intended as a sort of modern version of Art déco. Exclusive materials give the rooms a feeling of luxury and glamour.

Das Design des Clubs im 5. Stock des „Three on the Bund"-Gebäudes versteht sich als eine Art moderne Version des Art déco. Exklusive Materialien verleihen den Räumen eine Atmosphäre von Luxus und Glamour.

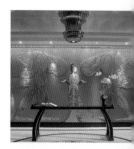

Le design du club au 5e étage du bâtiment « Three on the Bund » ressemble à une version moderne d'Art déco. Des matériaux exclusifs confèrent à ces lieux une atmosphère de luxe et de glamour.

El diseño de este club en el quinto piso del edificio "Three on the Bund", es una especie de versión moderna del Art déco. A través de los exclusivos materiales se consiguen crear espacios con una atmósfera de lujo y *glamour*.

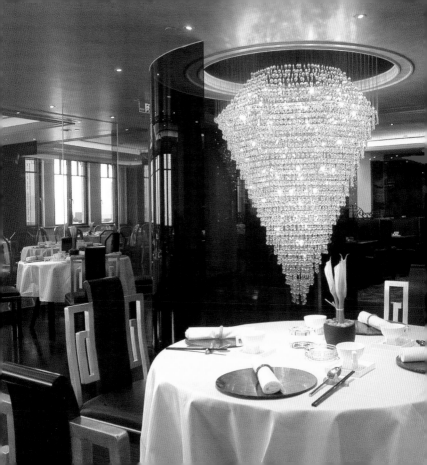

Mesa-Manifesto

OUT-2 Design

2004
748 Julu Lu
Jingan

Bright lofts, a kitchen sectioned off by large glass elements, gleaming concrete floors and halogen lighting: the Manifesto is a chic, trendy restaurant for Shanghai's international guests.

Helle Lofts, eine durch große Glaselemente abgetrennte Küche, glänzende Betonböden und Halogenbeleuchtung: Das Manifesto ist ein schickes Szene-Restaurant für das internationale Publikum Shanghais.

Des lofts clairs, une cuisine séparée par de grandes vitres, des sols en béton brillants et un éclairage halogène : Le Manifesto est un restaurant chic et branché pour le public international de Shanghai.

Lofts luminosos, una cocina separada por grandes tabiques de cristal, brillantes suelos de hormigón y una iluminación con lámparas halógenas: el Manifesto es un elegante restaurante de la escena de Shanghai pensado para el público internacional de la ciudad.

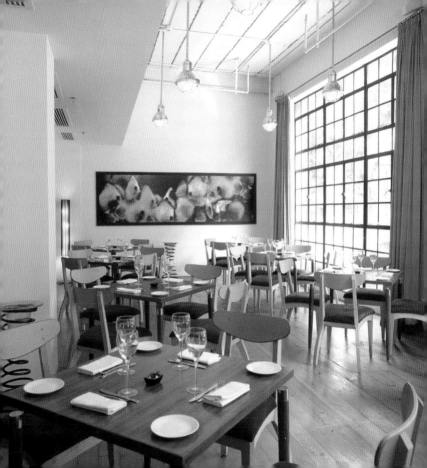

Shintori Null 2

Sakae Miura

2002
803 Julu Lu
Jingan

www.shintori.com

Whether it is the refectory, hall or James Bond backdrop: Shintori's minimalist design makes it one of Shanghai's most unusual restaurants. The walls and floors have exposed concrete surfaces. A large, open kitchen area is located on the front side of the hall space.

Refektorium, Werkshalle oder James-Bond-Kulisse: Sein minimalistisches Design macht das Shintori zu einem der ungewöhnlichsten Restaurants in Shanghai. Wände und Böden haben Sichtbetonoberflächen. An der Stirnseite des Hallenraums liegt ein großer offener Küchenbereich.

Réfectoire, halle d'usine ou coulisse de James Bond : son design minimaliste fait du Shintori l'un des restaurants les plus originaux de Shanghai. Les murs et les sols sont en béton apparent. Un grand espace cuisine ouvert se trouve au bout de la halle.

Un refectorio, un taller o el decorado de James Bond: su diseño minimalista convierte a Shintoria en uno de los restaurantes más insólitos de Shanghai. Las superficies de las paredes y los suelos son de hormigón visto. En el lado frontal del espacio se encuentra la amplia zona de la cocina abierta.

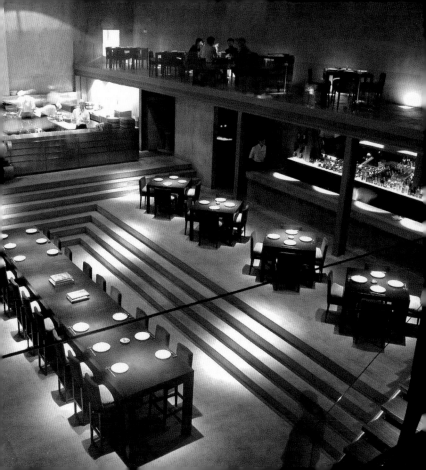

Crystal Jade Restaurant

Chanto Design

2002
6-7 South Block Xintiandi /
Xingye Lu
Luwan

www.xintiandi.com

Transparent screens made of red slats divide up the restaurant into different areas. The ambitious interior décor with precious woods and natural stone is designed down to the last detail of the lights.

Transparente Screens aus roten Lamellen gliedern das Restaurant in verschiedene Bereiche. Die ambitionierte Innenausstattung mit edlen Hölzern und Naturstein ist bis in die Details der Lampen gestaltet.

Les différents espaces du restaurant sont séparés par des écrans transparents en lamelles rouges. Des essences nobles à la pierre naturelle, sans oublier les lampes, le décor est ambitieux.

Pantallas transparentes de láminas rojas dividen el restaurante en diferentes áreas. La ambiciosa decoración interior, con maderas nobles y piedra natural, está elaborada hasta el detalle, incluyendo las lámparas.

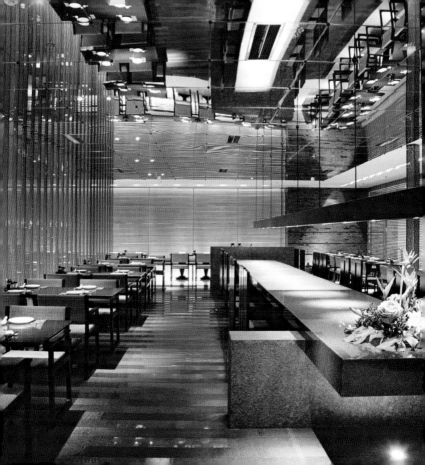

La Maison

Wood + Zapata

2001
23 South Block Xintiandi /
181 Taicang Lu
Luwan

www.xintiandi.com
www.wood-zapata.com

La Maison has two faces: while the restaurant is kept in warm color tones, the silver leather sofas and effective lighting in the nightclub create a rather cool and futuristic ambiance.

Das La Maison hat zwei Gesichter: Während das Restaurant in warmen Farbtönen gehalten ist, schaffen die silbernen Ledersofas und die effektvolle Beleuchtung des Nachtclubs ein eher kühles, futuristisches Ambiente.

La Maison a deux visages : les tons chauds prédominent dans la salle de restaurant, tandis que dans le night club avec ses canapés en cuir argenté et son éclairage à effets spéciaux, l'atmosphère est plutôt froide et futuriste.

La Maison tiene dos caras: mientras que en el restaurante predominan los colores cálidos, los sofás de cuero plateados y la espectacular iluminación del club nocturno crean un ambiente frío y futurista.

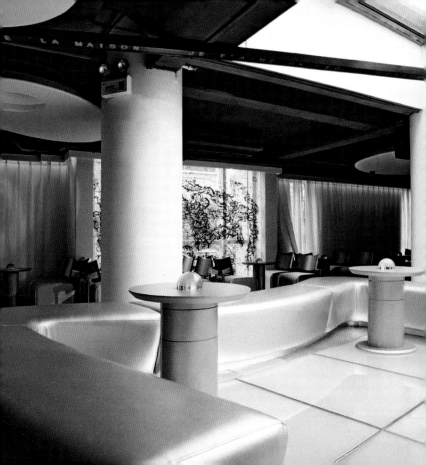

T8

Chanto Design

2001
8 North Block Xintiandi
Luwan

www.xintiandi.com

Brick walls, wall canopies of dark wood and effective lighting ensure a refined, stylish atmosphere. The restaurant's open kitchen is an additional attraction for guests.

Backsteinwände, Wandschirme aus dunklem Holz und eine effektvolle Beleuchtung sorgen für eine gediegene, stilvolle Atmosphäre. Die offene Küche des Restaurants ist eine zusätzliche Attraktion für die Gäste.

Des murs de briques, des paravents en bois foncé et un éclairage à effets spéciaux engendrent une atmosphère cossue et stylée. La cuisine ouverte du restaurant offre un attrait supplémentaire aux hôtes.

Las paredes de ladrillo, las pantallas de madera oscura y una iluminación efectista crean una atmósfera elegante y llena de estilo. La cocina abierta del restaurante es una atracción adicional para los clientes.

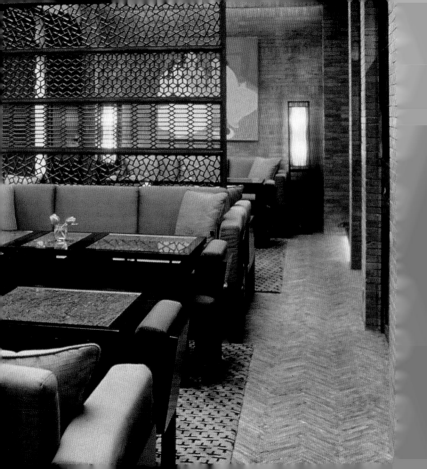

Yè Shanghai

Tony Chi & Associates

2001
6 North Block Xintiandi /
338 Huangpinan Lu
Luwan

www.elite-concepts.com
www.tonychi.com

The restaurant's modern architecture is integrated in a historic Shikumen building dating from 1928. The inner structure of the building was completely changed and transformed into a large, interconnecting room. However, numerous references to the building's history were preserved.

Die moderne Architektur des Restaurants integriert sich in ein historisches Shikumen-Gebäude aus dem Jahr 1928. Die innere Struktur des Hauses wurde völlig verändert und in einen großen, zusammenhängenden Raum verwandelt. Dennoch blieben vielfältige Bezüge auf die Geschichte des Gebäudes erhalten.

L'architecture moderne du restaurant s'intègre dans la maison historique (shikumen) de 1928. La structure intérieure de la maison a été complètement modifiée et transformée en un vaste espace cohérent. De nombreuses références à l'histoire de la maison ont cependant été conservées.

La moderna arquitectura del restaurante está integrada en un edificio histórico Shikumen del año 1928. La estructura interna de la casa se modificó completamente para conseguir un amplio espacio continuo. Aún así se han conservado muchos detalles que remiten a la historia del edificio.

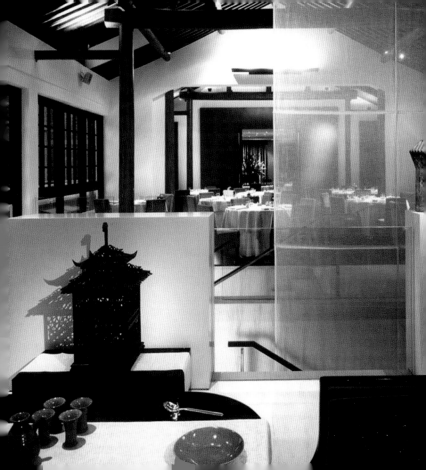

Fish & Co. Restaurant

Genco Berk

2005
333 Tianyueqiao Lu
Xuhui

www.intl-interiors.com

The restaurant's design is defined with "maritime" forms: wall claddings, tables and benches roll in wave-like shapes. The "flowing" forms of the suspended ceiling elements also underline this impression.

Das Design des Restaurants wird von „maritimen" Formen bestimmt: Wandverkleidungen, Tische und Sitzbänke sind wellenförmig geschwungen. Auch die „fließenden" Formen der abgehängten Deckenelemente unterstützen diesen Eindruck.

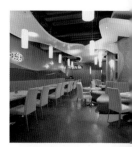

Le design du restaurant est déterminé par des formes « maritimes » : les revêtements muraux, les tables et les bancs présentent des formes ondulées. Les formes « fluides » des plafonds aménagés renforcent cette impression.

El diseño del restaurante se caracteriza por las formas "marítimas": las ondulaciones de los revestimientos de las paredes, de las mesas y de los bancos recuerdan a las olas. Las formas "fluidas" de los elementos colgantes de los techos acentúan también esta impresión.

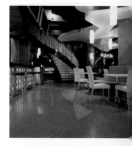

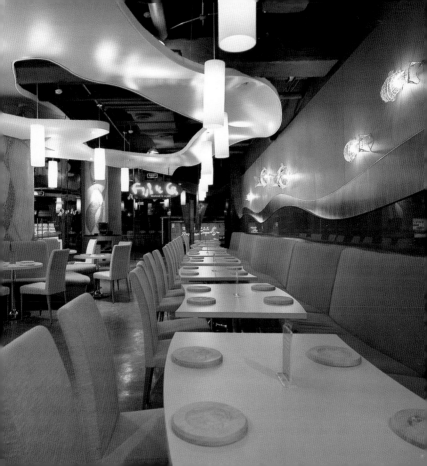

Evian Spa

dwp CL3 Architects Ltd., Alan Chan Design

2004
3 Zhongshan Dong 1-Lu (The Bund)
Huangpu

www.threeonthebund.com
www.cl3.com
www.alanchandesign.com

Purity, transparency and tranquility—the visitor can expect a different world in the Evian Spa than the loud and hectic surroundings of Shanghai. Five large and polished stone blocks in the spa's foyer refer to the meditative atmosphere of a Japanese rock garden.

Reinheit, Transparenz und Ruhe – im Evian Spa erwartet den Besucher eine Gegenwelt zur lauten und hektischen Umgebung Shanghais. Fünf große polierte Steinblöcke im Foyer des Spa verweisen auf die meditative Atmosphäre eines japanischen Felsengartens.

Propreté, transparence et tranquillité – le visiteur découvri dans l'Evian Spa tout le contra re d'un Shanghai bruyant et ag té. Les cinq grands blocs d pierre polis dans l'entrée du sp évoquent l'atmosphère médita tive d'un jardin de pierres.

Pureza, transparencia y tranquilidad: en Evian Spa el visitante encontrará el mundo opuesto al ambiente ruidoso y bullicioso de Shanghai. Los cinco grandes bloques de piedra pulida del vestíbulo del spa remiten a la atmósfera meditativa de un jardín de piedra japonés.

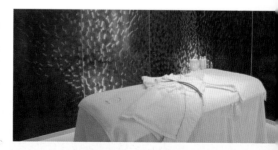

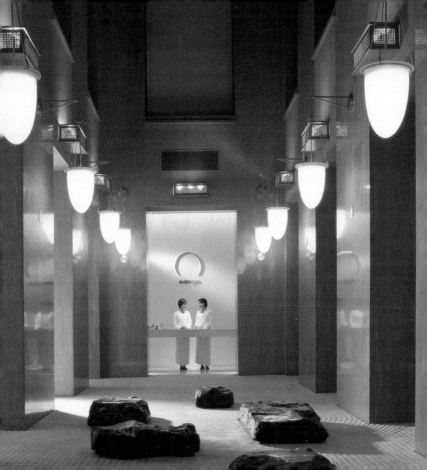

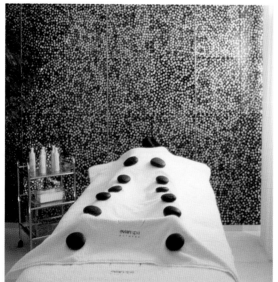

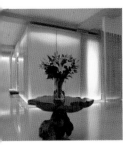

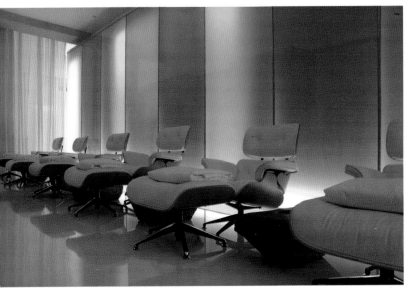

Shanghai Stadium

Shanghai Institute of Architectural Design & Research (SIADR)

1997
Tianyueqiao Lu
Xuhui

www.siadr.com.cn

The stadium for 80.000 spectators is dominated by a wave-like rising and falling roof construction. It consists of angular supports with a membrane of glass fiber layers stretched across. A visit to this impressive construction is worthwhile, even if you are not a sports fan.

Das Stadion für 80.000 Zuschauer wird durch eine sich wellenförmig auf- und abschwingende Dachkonstruktion beherrscht. Sie besteht aus winkelförmigen Trägern, über die eine Membran aus beschichteten Glasfasern gespannt ist. Selbst für nicht an Sport Interessierte lohnt ein Besuch des eindrucksvollen Baus.

Le stade prévu pour 80 00 spectateurs est coiffé d'un to ondulé imposant composé c supports en forme d'angle su lesquels est tendue une mem brane en fibre de verre traité Même ceux qui ne s'intéresse pas au sport doivent venir visite cette création architecturale im pressionnante.

Las ondulaciones de la cubierta de este estadio para 80.000 espectadores domina la impresión general de la construcción. Sus soportes angulares sostienen una membrana de fibra de vidrio revestida que se extiende por todo el graderío. Merece la pena visitar esta impresionante instalación, incluso si no se es amante del deporte.

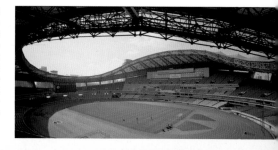

Sports Complex Anting New Town

Behnisch, Behnisch & Partner

2008
Anting

www.behnisch.com

The generous complex consists of three halls, each of different dimensions, and linked to one another by a bridge. The body of each hall is kept flat and with crystalline roofs, they react in a highly sensitive way to the gently rolling landscape of the immediate surroundings.

Der großzügige Komplex besteht aus drei unterschiedlich dimensionierten, durch eine Brücke miteinander verbundenen Hallen. Mit flach gehaltenen Körpern und kristallin geformten Dächern reagieren sie ausgesprochen sensibel auf die sanft modulierte Landschaft ihrer unmittelbaren Umgebung.

Ce complexe spacieux comprend trois halles de dimensions différentes qui sont reliées par une passerelle. Avec des bâtiments plats et des toits en forme de cristaux, les halles se fondent parfaitement dans le paysage harmonieux alentour.

Este amplio complejo está compuesto por tres pabellones de diferentes dimensiones unidos entre sí por un puente. La horizontalidad de los volúmenes y las estructuras cristalinas de las cubiertas se adaptan extraordinariamente a las suaves formas del paisaje que los rodea.

Shanghai
International Circuit

Tilke GmbH

2004
2000 Yining Lu
Jiading

www.icsh.sh.cn/en
www.tilke.com

The racing control tower, main spectator stands and press center together form two major gates above the pit-stop lane of the new racing track. The roofs of the adjacent stands are suspended from high masts. The inspiration for the roof shapes is the leaves of the lotus flower.

Der Rennkontrollturm, die Haupttribünen und das Pressezentrum bilden zusammen zwei große Tore über der Boxengasse der neuen Rennstrecke. Die Dächer der Nebentribünen sind von hohen Masten abgespannt. Die Dachformen sind von den Blättern einer Lotosblume inspiriert.

La tour de contrôle du champ de course, les tribunes principales et le centre de presse constituent deux grandes portes au-dessus du couloir des écuries du nouveau circuit. Les toits des tribunes annexes sont fixés à de grands mâts. Ils sont inspirés de la forme des feuilles de lotus.

La torre de control del circuito, las tribunas principales y el centro de la prensa forman dos grandes puertas sobre los boxes de los nuevos recorridos. Las cubiertas de las tribunas laterales están arriostradas por grandes postes y sus formas están inspiradas en los pétalos de una flor de loto.

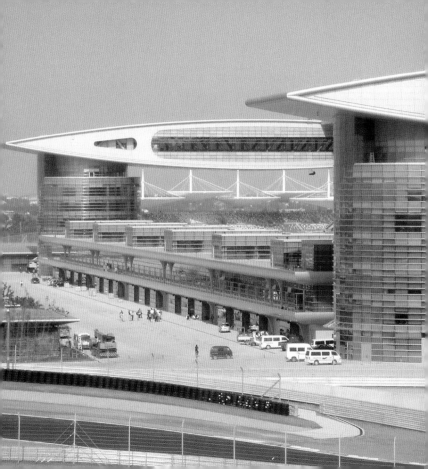

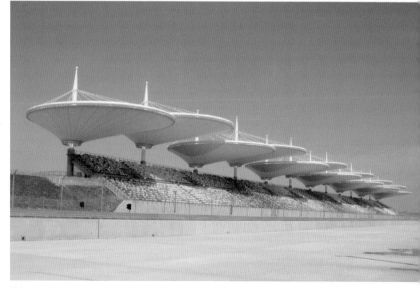

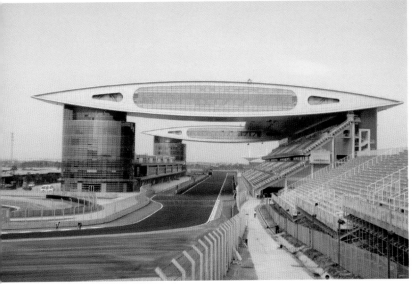

Qi Zhong Tennis Center

Shanghai Institute of Architectural Design & Research (SIADR)

2005
Zhongqing Lu
Minhang

www.siadr.com.cn

Asia's biggest tennis center is distinguished by an impressive roof construction, with eight enormous segments being reminiscent of magnolia petals. The individual roof segments can be rotated to form one continuous and closed roof covering above center court.

Das größte Tennis-Center Asiens zeichnet sich durch seine beeindruckende Dachkonstruktion aus, deren acht riesige Segmente an die Blütenblätter einer Magnolie erinnern sollen. Durch Drehung fügen sich die einzelnen Segmente zu einer durchgängig geschlossenen Dachfläche über dem Centrecourt zusammen.

Le plus grand centre de tenni d'Asie se distingue par un to impressionnant dont les hu segments géants rappellent le pétales des fleurs de magnolia En tournant, les segments s'as semblent et forment un toit com plètement fermé au-dessus d court de tennis.

El mayor centro de tenis de Asia destaca por la impresionante construcción de su cubierta. Sus ocho segmentos de grandes dimensiones evocan los pétalos de una magnolia. Al girarlos, estos elementos se acoplan entre sí formando una superficie continua y cerrada sobre las pistas.

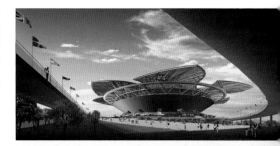

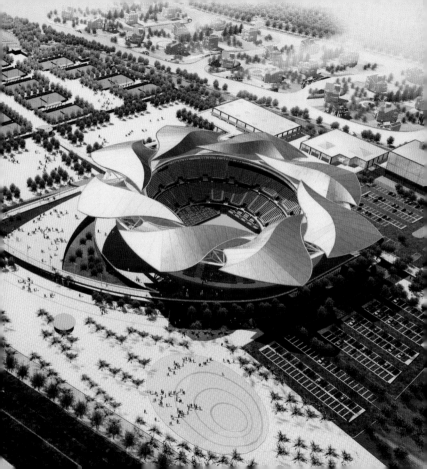

to shop . mall
 retail
 showrooms

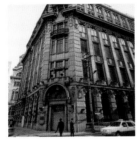
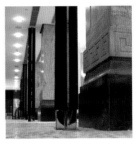
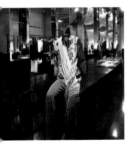
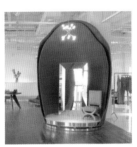
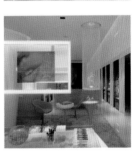
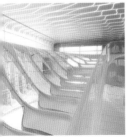

Three on the Bund

Michael Graves

2004
3 Zhongshan Dong 1-Lu (The Bund)
Huangpu

www.threeonthebund.com
www.michaelgraves.com

After a complete program of renovation, a lavishly decorated, historic façade was turned into an elegant cover for exclusive stores, restaurants and galleries. Michael Graves's first Chinese project incorporates traditional forms with the occasional modern interpretation and together with objective, contemporary design, they ensure exciting contrasts.

Eine üppig dekorierte historistische Fassade wurde durch eine umfassende Sanierung zur noblen Hülle für exklusive Geschäfte, Restaurants und Galerien. Beim ersten chinesischen Projekt von Michael Graves sorgen traditionelle Formen in mitunter moderner Interpretation zusammen mit dem sachlichen Design der Gegenwart für reizvolle Kontraste.

Après une restauration générale, ce bâtiment somptueux abrite derrière une façade historique richement décorée des magasins, des galeries et des restaurants exclusifs. Le mariage de formes traditionnelles partiellement modernisées et d'éléments sobres du design contemporain dans ce premier projet chinois de Michael Graves présente des contrastes saisissants.

La histórica fachada de profusa decoración fue completamente saneada para convertirla en la noble envoltura de exclusivas tiendas, restaurantes y galerías. En este proyecto, el primero realizado por Michael Graves en China, la moderna interpretación de las formas tradicionales establece un interesante contraste con la objetividad del diseño moderno.

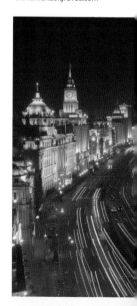

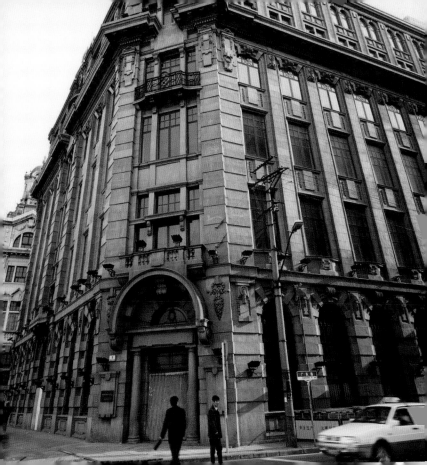

Three Retail

Jimin Lee, Angelo Negro, Atelier Pacific, SURV

2004
3 Zhongshan Dong 1-Lu (The Bund,
Huangpu

www.threeonthebund.com
www.atelierpacific.com.hk

In Three Retail, exclusive fashion labels, shoes and cosmetics as well as top-class wines are on offer. Two large, freestanding dressing-room cabinets look like cocoons, where trying on clothes turns into the act of staging a total transformation.

In Three Retail werden exklusive Modelabels, Schuhe und Kosmetika, aber auch erstklassige Weine angeboten. Zwei große, frei stehende Umkleidekabinen wirken wie Kokons, in denen die Anprobe der Kleider als Akt der Verwandlung inszeniert wird.

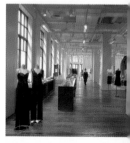

Three Retail offre aux visiteurs des marques à la mode, des chaussures et des produits de beauté exclusifs ainsi que des vins de premier choix. Deux grandes cabines d'essayage isolées ressemblent à des cocons dans lesquels l'essayage des vêtements est mis en scène comme un acte de métamorphose.

En Three Retail se pueden encontrar exclusivas marcas de moda, de zapatos y de cosméticos, además de vinos de primera clase. Dos grandes cabinas independientes asemejan capullos en los que probarse la ropa se escenifica como un acto de metamorfosis.

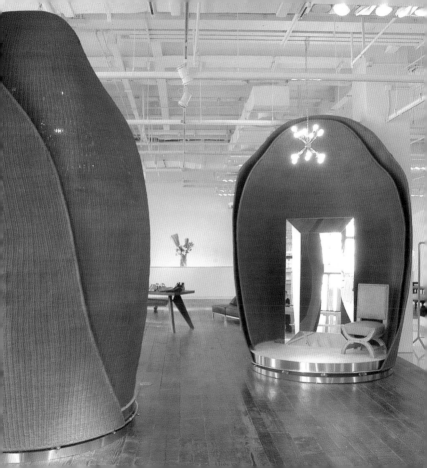

Giorgio Armani

Claudio Silvestrin architects

2004
3 Zhongshan Dong 1-Lu (The Bund)
Huangpu

www.giorgioarmani.com
www.claudiosilvestrin.com

Black floors and furniture as well as stainless-steel claddings for the pillars and ceiling make an irritating, labyrinth-like and mirrored cabinet out of the sales floor.

Schwarze Böden und Möbel sowie Edelstahlverkleidungen der Stützen und Decke machen aus dem Verkaufsraum des Shops ein irritierendes, labyrinthisches Spiegelkabinett.

Les sols et les meubles noirs, ainsi que les revêtements en acier des supports et du plafond, font ressembler cet espace à un cabinet de miroirs labyrinthique troublant.

El negro de los suelos y del mobiliario, y los revestimientos de acero de las columnas y los techos, convierten la superficie comercial de la tienda en una sala de espejos desconcertante y laberíntica.

166

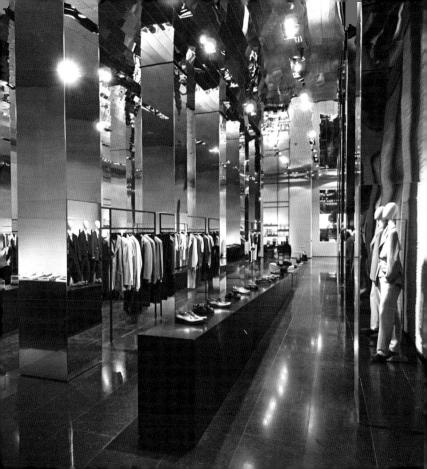

Emporio Armani

Massimiliano & Doriana Fuksas

2004
3 Zhongshan Dong 1-Lu (The Bund)
Huangpu

www.emporioarmani.com
www.fuksas.it

Illuminated and long stretches of glass pipes drop like icicles from the ceiling and spread a gleaming, bright light that reflects on the highly polished floors. The unusual furnishing gives the shop a fascinating and slightly surreal atmosphere.

Lang gestreckte, leuchtende Glasröhren hängen wie Eiszapfen von der Decke und verbreiten strahlend helles Licht, das sich in den hochpolierten Böden spiegelt. Die ungewöhnliche Ausstattung verleiht dem Shop eine faszinierende, leicht surreale Atmosphäre.

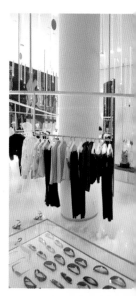

De longs tubes de verre lumineux pendent comme des glaçons du plafond et diffusent une lumière claire et lumineuse qui se reflète dans des sols reluisants. Ce décor inhabituel confère au shop une atmosphère fascinante et un peu surréaliste.

Unos tubos iluminados y alargados de cristal cuelgan del techo como témpanos de hielo e irradian una luz clara que se refleja en los pulidos suelos. Su inusual decoración dota a la tienda de una atmósfera fascinante y ligeramente surrealista.

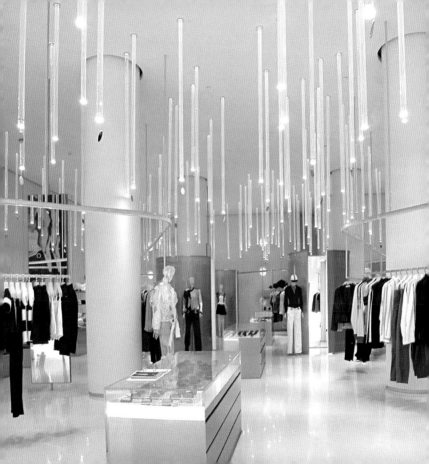

Bund 18 Renovation

Kokaistudios

2004
18 Zhongshan Dong 1-Lu
(The Bund)
Huangpu

www.bund18.com
www.kokaistudios.com

The former bank building dating from 1923 retained its original beauty and elegance with a lavish, two-year renovation project. Flagship stores, bars and restaurants are now located on seven floors.

Das ehemalige Bankgebäude aus dem Jahr 1923 gewann durch eine aufwändige, über zwei Jahre dauernde Renovierung seine ursprüngliche Schönheit und Eleganz zurück. Auf sieben Geschossen finden sich nun Flagship-Stores, Bars und Restaurants.

L'ancienne banque qui date de 1923 a retrouvé sa beauté et son élégance d'autrefois après une rénovation de grande envergure qui a duré près de deux ans. Aujourd'hui, ce sont des Flagship-Stores, des bars et des restaurants qui occupent les sept étages de ce bâtiment.

El antiguo edificio del banco, del año 1923, pudo recobrar su belleza y elegancia originales gracias a los trabajos de saneamiento que se llevaron a cabo durante dos años. Sus siete plantas albergan boutiques, bares y restaurantes.

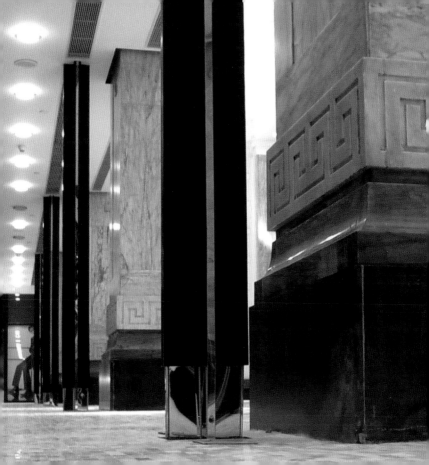

Cartier

Bruno Moinard

2004
18 Zhongshan Dong 1-Lu (The Bund)
Huangpu

www.cartier.com

Cartier's flagship store is located on the ground floor of Bund 18. The restriction to minimal furniture with timeless elegance and refined, light wood panels creates a restrained atmosphere, but without discarding the hint of luxury. Playful chandeliers create colorful accents.

Im Erdgeschoss von Bund 18 befindet sich der Cartier Flagship-Store. Die Beschränkung auf wenige Möbel von zeitloser Eleganz und edle Paneele aus hellem Holz erzeugt eine zurückhaltende Stimmung, ohne auf die Anmutung von Luxus zu verzichten. Verspielte Kronleuchter setzen farbige Akzente.

Le Flagship-Store de Cartier se trouve au rez-de-chaussée du Bund 18. Un décor limité à quelques meubles d'une élégance intemporelle et de magnifiques lambris en bois clair engendrent une atmosphère empreinte de retenue mais sans renoncer à une touche de luxe. Des lustres fantaisie apportent une note de couleur.

En la planta baja del Bund 18 se encuentra la tienda de Cartier. Su limitado mobiliario de elegancia atemporal y los paneles de madera clara de las paredes, crean un ambiente sobrio pero sin renunciar al lujo. Las alegres arañas ponen la nota de color.

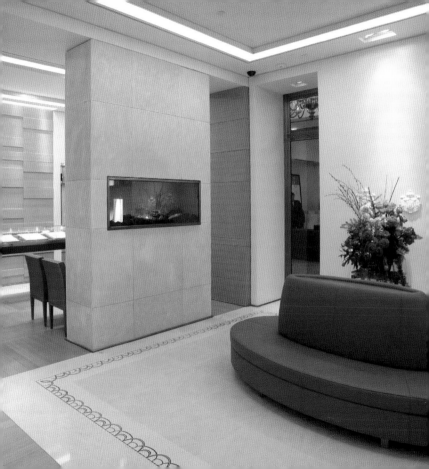

Lancôme IFC

Jean Marie Massaud & Daniel Pouzet

2004
1185 Nanjing Xilu
Jingan

www.lancomechina.com
www.massaud.com

This salon appears as part shop and part lounge. Gentle pink tones in front of light walls and floors create a feminine atmosphere as the perfect setting for the products of this cosmetics manufacturer.

Halb als Shop, halb als Lounge erscheint dieser Salon. Zarte Rosatöne vor hellen Wänden und Böden schaffen eine feminine Atmosphäre als perfekten Rahmen für die Produkte des Kosmetikherstellers.

Ce salon est mi-shop, mi-lounge. La douceur des tons rosés devant des murs et des sols clairs créent une atmosphère féminine qui est le cadre idéal pour la présentation des produits de cette marque.

Este salón parece ser algo intermedio entre una tienda y una sala de estar. Los delicados tonos rosa se combinan con los colores claros de las paredes y los suelos creando una atmósfera femenina, el marco perfecto para el producto de esta empresa.

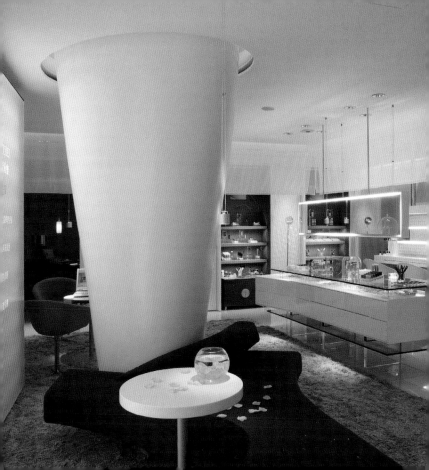

Xintiandi

Wood + Zapata

1998
Taicang Lu
Luwan

www.xintiandi.com
www.wood-zapata.com

The district with a variety of first-rate bars, restaurants and shops is impressive for its direct contrast of old and new. The northern part is dominated by renovated, but largely altered Shikumen houses, whilst in the southern part, a modern leisure complex dominates with a floor space of over 25.000 m².

Das Quartier mit einer Vielzahl erstklassiger Bars, Restaurants und Shops beeindruckt durch den unmittelbaren Kontrast von Alt und Neu. Im nördlichen Block herrschen dabei renovierte, jedoch weitgehend veränderte Shikumen-Häuser vor, während ein moderner Freizeitkomplex mit über 25.000 m² Geschossfläche den südlichen Teil dominiert.

Le quartier compte une multitude de bars, de restaurants et de shops de grande classe qui frappent par la coexistence contrastée de l'ancien et du nouveau. Dans le nord, ce sont pourtant les maisons traditionnelles (shikumen) restaurées mais aussi transformées qui dominent. Le sud se distingue par son complexe de loisirs moderne d'une surface de plus de 25.000 m².

Este barrio, con una gran variedad de bares, restaurantes y tiendas de primera categoría, impresiona por el contraste directo entre lo nuevo y lo viejo. En el bloque norte dominan las casas Shikumen, renovadas y en gran parte transformadas, mientras que en la parte sur destaca un moderno complejo para actividades de tiempo libre con una superficie superior a los 25.000 m².

Reebok Flagship Store

Contemporary Architecture Practice

2006
Madang Lu
Luwan

www.c-a-p.net

Computer-generated forms transmit a pull-like energy flow and beyond a 3-D effect they produce the illusion of visibly rapid speed. An area filled with TV screens is joined onto the real sales room and clients are invited to follow current sporting events.

Computergenerierte Formen vermitteln einen sogartigen Bewegungsfluss und erzeugen über die dritte Dimension hinaus die Illusion sichtbarer rasanter Geschwindigkeit. Ein dem eigentlichen Verkaufsraum angeschlossener Bereich mit Bildschirmen lädt dazu ein, aktuelle Sportereignisse zu verfolgen.

Des formes générées par ordinateur donnent une impression de mouvement aspirant et créent au-delà de la troisième dimension l'illusion d'une vitesse vertigineuse visible. La zone des écrans rattachée à l'espace de ventes invite à suivre les actualités sportives.

Las formas generadas por ordenador transmiten la sensación de un movimiento similar al de un remolino y crean, más allá de la tercera dimensión, la ilusión de una velocidad vertiginosa. Un espacio con televisiones anexionado al área de venta, invita a seguir los últimos acontecimientos deportivos.

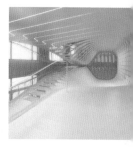

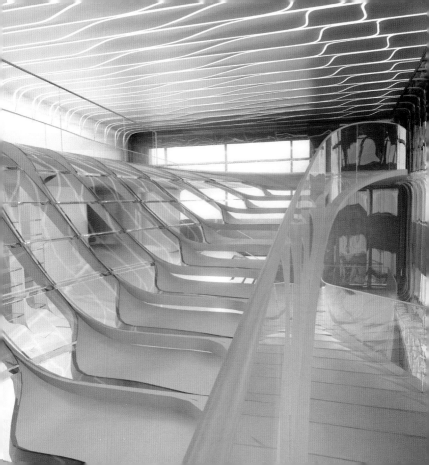

Bayer Polymer Technical Center

Architekten Fischer + Fischer

2002
Shenjang Lu / Beiwu Lu
Jinquao Industrial Town

www.bayerchina.com.cn
www.architekten-fischer-fischer.de

This secret shrine lights up in the dark in the most diverse colors. It belongs to a research center for the material, Makrolon, and is used as a representation and exhibition building. Makrolon partition posts were accordingly used for all façade surfaces as well as the main gates, which are almost as high as the building.

Dieser geheimnisvolle Schrein leuchtet bei Dunkelheit in den unterschiedlichsten Farben. Er gehört als Repräsentations- und Ausstellungsgebäude zu einem Forschungszentrum für den Werkstoff Makrolon. Entsprechend wurden für sämtliche Fassadenflächen sowie die annähernd gebäudehohen Tore Makrolon-Doppelstegplatten verwendet.

Dans l'obscurité, ce sanctuaire mystérieux brille dans toutes les couleurs. Ce bâtiment de représentation et d'exposition fait partie d'un centre de recherche pour le macralon. C'est pourquoi des plaques en macralon ont été utilisées pour toutes les surfaces de la façade ainsi que pour les portes presque aussi hautes que le bâtiment.

Este misterioso cofre se ilumina en la oscuridad en los más diversos colores. El edificio de representaciones y exposiciones pertenece a un centro de investigación sobre el material Makrolon. Por eso, para las superficies de la fachada y las puertas de acceso, de la misma altura que el edificio, se han empleado placas de Makrolon con nervaduras dobles.

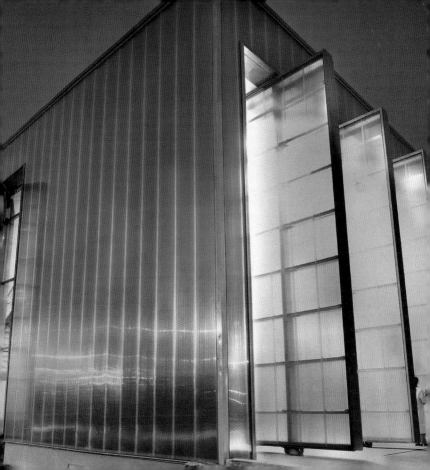

Index Architects / Designers

Index Architects / Designers

Index Structural Engineers

Index Districts

Index Districts

Photo Credits

Imprint

Copyright © 2005 teNeues Verlag GmbH & Co. KG, Kempen

Published by teNeues Publishing Group

teNeues Book Division	teNeues Publishing Company	teNeues Publishing UK Ltd.
Kaistraße 18	16 West 22nd Street	P.O. Box 402
40221 Düsseldorf, Germany	New York, N.Y. 10010, USA	West Byfleet
Phone: 0049-(0)211-99 45 97-0	Phone: 001-212-627-9090	KT14 7ZF, UK
Fax: 0049-(0)211-99 45 97-40	Fax: 001-212-627-9511	Phone: 0044-1932-403 509
E-mail: books@teneues.de		Fax: 0044-1932-403 514

Press department: arehn@teneues.de
Phone: 0049-(0)2152-916-202

teNeues France S.A.R.L.
4, rue de Valence
75005 Paris, France
Phone: 0033-1-55 76 62 05
Fax: 0033-1-55 76 64 19

www.teneues.com
ISBN 3-8327-9023-3

Bibliographic information published by Die Deutsche Bibliothek
Die Deutsche Bibliothek lists this publication in the Deutsche Nationalbibliografie;
detailed bibliographic data is available in the Internet at http://dnb.ddb.de

Editorial Project: fusion-publishing GmbH Stuttgart . Los Angeles
Edited by Christian Datz & Christof Kullmann
Concept by Martin Nicholas Kunz
Layout & Pre-press: Thomas Hausberg
Imaging by Jan Hausberg
Map: go4media. – Verlagsbüro, Stuttgart

www.fusion-publishing.com
Translation: SAW Communications,
Dr. Sabine A. Werner, Mainz
English: Dr. Suzanne Kirkbright
French: Dominique Le Pluart
Spanish: Silvia Gomez de Antonio

Printed in Italy

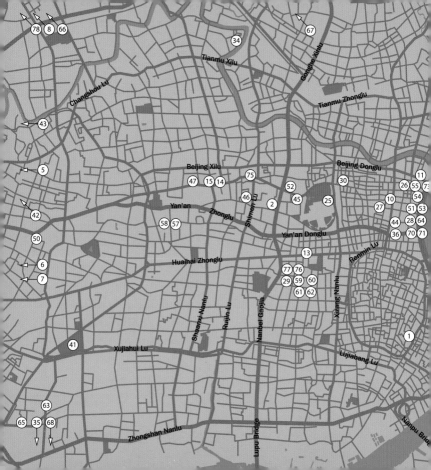

Legend

191

and : guide

Size: 12.5 x 12.5 cm / 5 x 5 in. (CD-sized format)
192 pp., Flexicover
c. 200 color photographs and plans
Text in English, German, French, Spanish

Other titles in the
same series:

Amsterdam
ISBN: 3-8238-4583-7

Barcelona
ISBN: 3-8238-4574-8

Berlin
ISBN: 3-8238-4548-9

Chicago
ISBN: 3-8327-9025-X

London
ISBN: 3-8238-4572-1

Los Angeles
ISBN: 3-8238-4584-5

Munich
ISBN: 3-8327-9024-1

New York
ISBN: 3-8238-4547-0

Paris
ISBN: 3-8238-4573-X

Tokyo
ISBN: 3-8238-4569-1

Vienna
ISBN: 3-8327-9026-8

To be published in the
same series:

Athens
Cape Town
Copenhagen
Hamburg
Hong Kong
Madrid
Miami

Milan
Moscow
Rome
San Francisco
Singapore
Stockholm
Sydney

teNeues

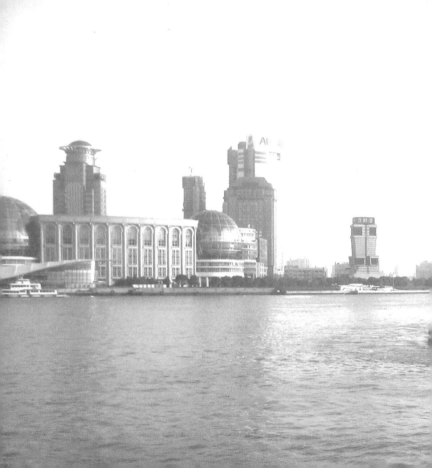